IMAGES
of America

MATAGORDA
COUNTY

IMAGES
of America

MATAGORDA
COUNTY

Matagorda County Museum Association

ARCADIA
PUBLISHING

Published by Arcadia Publishing
Charleston, South Carolina

Printed in the United States of America

Library of Congress Catalog Card Number: 2008921581

For all general information contact Arcadia Publishing at:
Telephone 843-853-2070
Fax 843-853-0044
E-mail sales@arcadiapublishing.com
For customer service and orders:
Toll-Free 1-888-313-2665

Visit us on the Internet at www.arcadiapublishing.com

For Mary Belle, an inspiration to us all

CONTENTS

ACKNOWLEDGMENTS

Since the Matagorda County Museum Association was founded in 1963, hundreds of volunteers have contributed tens of thousands of hours to preserve the history of Matagorda County. They helped build an extraordinary museum and children's museum, as well as remarkable Archives and Collections Departments. It is impossible to thank all of those volunteers individually, but without their hard work and their love of local history, this book would not have been possible. The Matagorda County Museum's Archives Department offers a treasure trove of fascinating stories and information about the community's history. Its collection of photographs is particularly impressive and provided all the images that appear in this book. The staff members and volunteers who maintain these collections have earned immeasurable gratitude from not only the museum association, but also the community as a whole.

We wish to thank the board of trustees of the Matagorda County Museum for their unconditional support and excitement for this book, Jennifer Rodgers and Mary Belle Ingram for sorting through thousands of photographs and captioning each one selected, and Sarah Higgins for putting it all together. We also wish to thank our editor at Arcadia Publishing, Kristie Kelly, for her guidance and gentle reminders when we needed them.

INTRODUCTION

The name Matagorda, Spanish for "thick brush," was derived from the canebrakes that formerly lined the shore of Matagorda Bay. Crossed by the once highly flood-prone Colorado River, which bisects it from north to south, the county extends across 1,612 square miles of mostly open prairie. The Colorado River and the county's location on the Gulf Coast of Texas shaped not only the contour of the land, but also the agriculture, livelihoods, recreation, bravado—and yes, even the spirit of the citizens of Matagorda County.

A logjam on the Colorado that collected for nearly 100 years determined who received irrigation. The relocation of the county courthouse changed the fabric of the county's government, festivals, and population. Hurricanes, floods, and fires cleared entire city blocks, but none were enough to break the spirit of the people. Images in this book give readers a glimpse of these and other stories that connect the people of the county with their colorful pasts.

Alonso Álvarez de Pineda mapped the Texas coastline in 1519, but Cabeza de Vaca, who in 1528 passed through what later became Matagorda County, conducted the first recorded European expedition into the Texas interior. In 1684, the French explorer René-Robert Cavelier, Sieur de La Salle left France with four ships in search of the mouth of the Mississippi River. Because La Salle's maps showed the river's mouth incorrectly, he eventually landed at Matagorda Bay, nearly 500 miles away from his destination. After three of the ships were lost, the remaining ship, *La Belle*, was sunk during a violent storm and lay on the bottom of the bay for more than 300 years. In 1995, the Texas Historic Commission, working from old Spanish maps, finally found *La Belle*'s watery grave. More than a million artifacts were extracted, many of which are on display at the Matagorda County Museum. The museum and other educational pursuits in the county are documented with early photographs of schools and schoolchildren.

Settlement by Anglo Americans began in 1822, when a schooner landed immigrants for Stephen F. Austin's colony at the mouth of the Colorado River. In events leading up to the Texas Revolution, according to some sources, members of the district of Mina at the Convention of 1832 were actually people from the Matagorda area rather than from Bastrop County. Volunteerism and civic pride run deep here, and several photographs show early parades and a monument dedication on the courthouse square.

It is said that the term "maverick" was born in Matagorda County. When an absentee landlord, Sam Maverick, was paid for a debt with cattle, he put them on Matagorda Island and did little else to tend them. Eventually, unbranded calves from the herd made their way to the mainland. When cowboys found one of these calves, they called it "a Maverick," a term that eventually came to mean anything or anyone that was separated from the mainstream. Readers are given a snapshot of early farming and ranching in the county, including the one showing the first livestock show in 1938 and a chuck wagon on the trail.

Throughout the years, one thing remains unchanged: the indomitable spirit of Matagorda County's people. It is a wonderful voyage to be able to look back and appreciate eras gone by, value what our ancestors accomplished, and admire them for the challenges they survived. We hope you enjoy the journey!

One

OUR FOUNDING FATHERS
CITY AND COUNTY GOVERNMENT

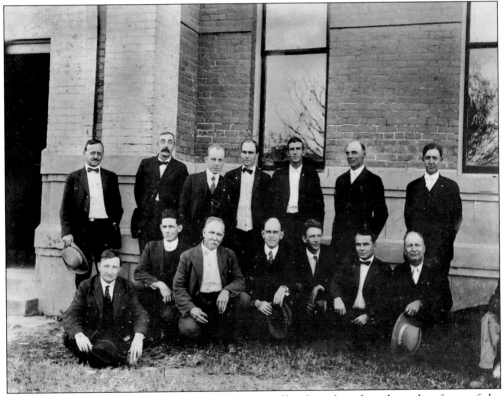

COUNTY OFFICIALS. In 1919, Matagorda County officials gathered to the right of one of the courthouse entrances for this photograph. From left to right are (kneeling) R. A. Kleska, county auditor Amos Lee, county treasurer George E. Serrill, district clerk W. C. Foulks, county commissioners Henry Sander and V. T. Harper, and county judge J. F. Perry; (standing) Sheriff Bert Carr, county superintendent W. F. Pack, county clerk J. T. Bond, janitor W. L. Douglas, collector of taxes T. H. Castleton, county attorney W. E. Davant, and county commissioners J. B. Hawkins, and Jim Pyle (paritally off camera).

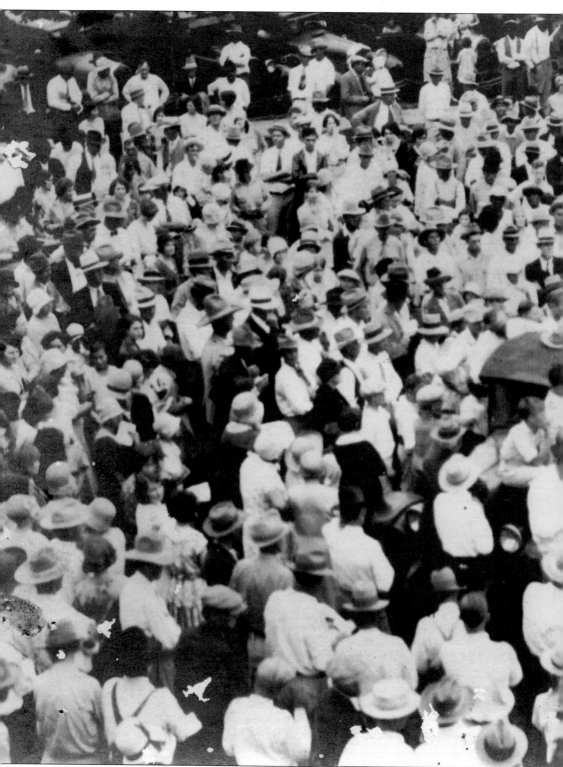

ELECTION RETURNS. Matagorda County citizens anxiously await returns during an election in

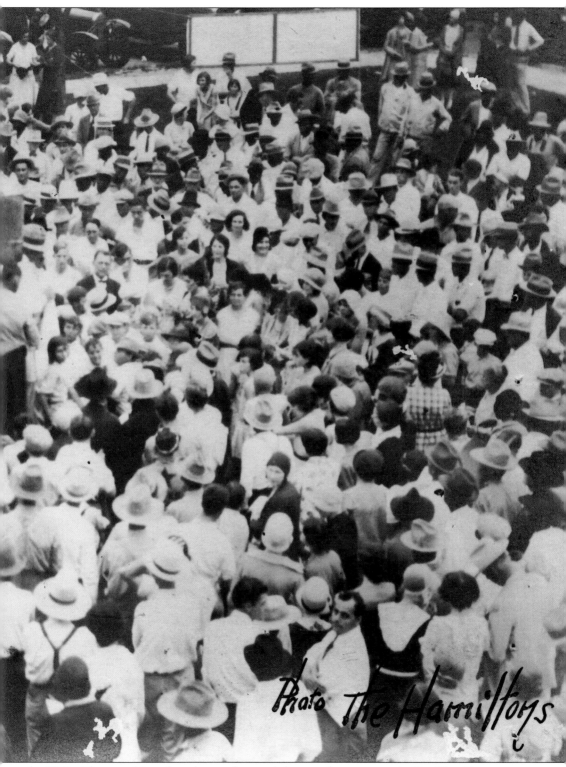

Photo The Hamiltons

the 1920s. The crowd is gathered on and around the courthouse square in Bay City, Texas.

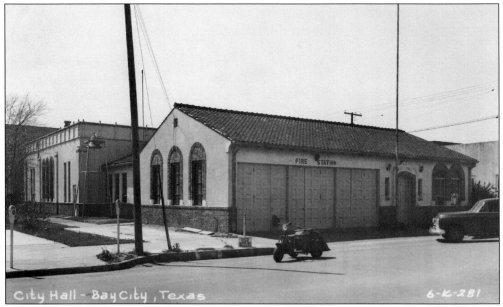

OLD CITY HALL. The original city hall housed several fire trucks in addition to the city's offices. The space was used to house the Matagorda County Museum after the new city hall was constructed across the street in 1965. Today the city court and judges' offices are located in the building.

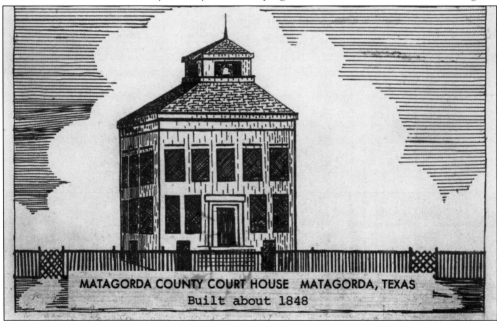

FIRST COUNTY COURTHOUSE. The two-story wooden building was built in 1849 in Matagorda, Texas, but was destroyed by a hurricane five years later. After the destructive storm, the courthouse was rebuilt using the original plans. It was damaged again in 1875 by another hurricane and throughout the years received many repairs because of storms. After the county seat was moved to Bay City, the building was used as a community center and justice of the peace office before being sold in 1902. George Burkhart Culver bought the building and moved it to the bay front. It served as a hotel and restaurant until it was destroyed by a fire on August 29, 1937.

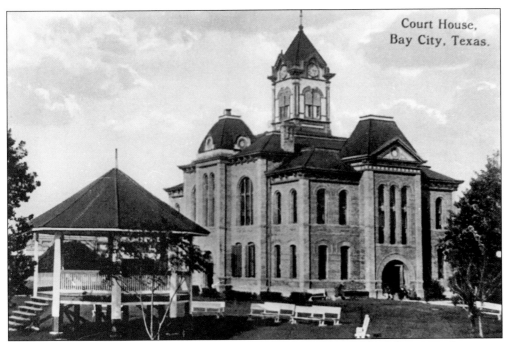

Court House,
Bay City, Texas.

SECOND COUNTY COURTHOUSE AND BANDSTAND. In 1894, voters elected to move the county seat from Matagorda to Bay City, Texas. The new courthouse was completed on May 12, 1896, at a cost of $30,000. The bandstand, added around 1907, became a stage for many political and patriotic rallies and band concerts. It was placed first on the southeast corner of the courthouse square then later moved to the southwest corner, where it remained until 1963, when it was moved for the demolition and construction of the new courthouse. It is now situated at the corner of Sixth Street and Avenue I, and received a Texas Historical Landmark in 1967.

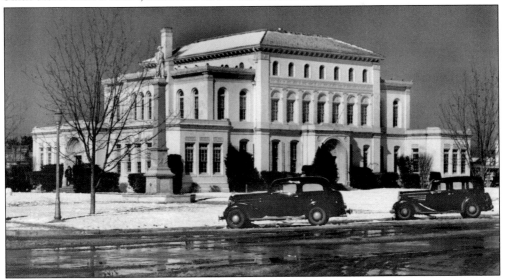

REMODELED COURTHOUSE. In 1928, the courthouse underwent an extensive remodeling. The total bids for the construction, plumbing, heating, and electrical work came to $57,457. North and south wings were added, the clock tower and original cornerstone were removed, and the structure was covered with stucco and painted white. The final result resembled Spanish architecture.

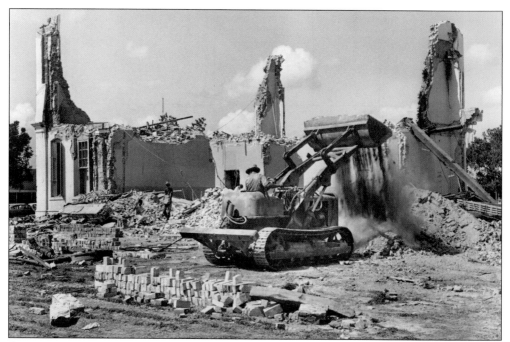

COURTHOUSE DEMOLITION. Demolition of the remodeled 1928 courthouse began in July 1963 so a more modern courthouse could be built and underground parking added. This photograph, taken on August 20, 1963, demonstrates an A. C. Enterprise crew working diligently so construction on the new courthouse could begin as soon as possible.

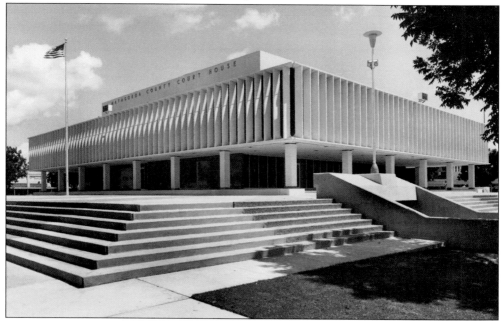

THIRD COURTHOUSE. A bid of $1,282,129.04 was accepted to build the new courthouse. Construction began on December 10, 1963, and was completed in 1965 at a cost of $1.6 million. It was built as a large structure with spacious offices and an underground parking facility. A dedication ceremony was held on September 15, 1965.

Two

AND THEN THE SEEDS GREW
FARM AND RANCH SCENES

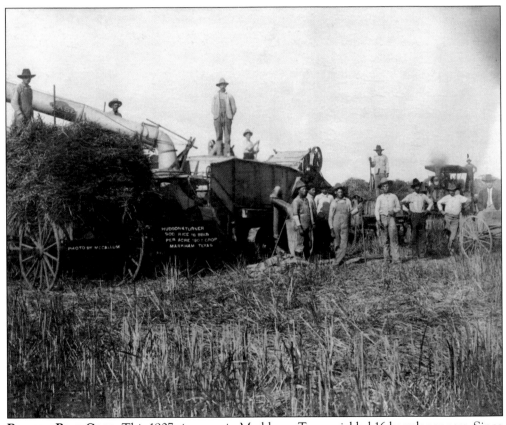

BUMPER RICE CROP. This 1907 rice crop in Markham, Texas, yielded 16 barrels per acre. Since this was above the average yield for that era, it warranted a celebratory photograph.

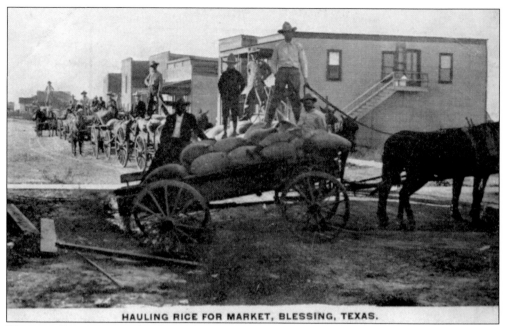

HAULING RICE FOR MARKET, BLESSING, TEXAS.

HAULING RICE. In 1910, farmhands have completed the backbreaking task of loading rice sacks onto a mule-drawn buckboard in Blessing, Texas, and stand atop their harvest as they head to market.

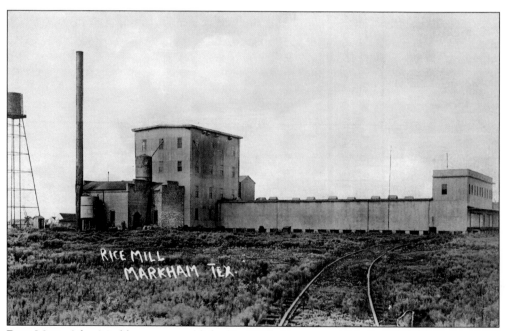

RICE MILL. After Markham was established in 1903, the town quickly flourished, and a rice mill was soon built. This rice mill was in operation until a fire destroyed it around 1912.

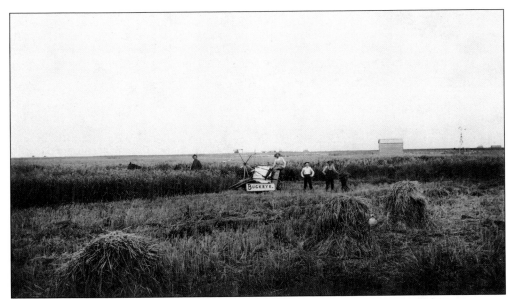

SHOCKING RICE. Rice farmers in Buckeye take time out from the shocking process to pose for this photograph around 1907.

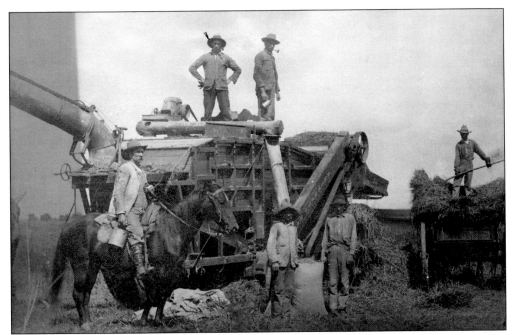

THRESHING MACHINE. Early Matagorda County resident John Mikalson stands with his hands on his hips alongside other rice farmers from the Buckeye and Markham areas. They are all involved in the 1907 rice harvest and are working on and around a threshing machine, a machine that separates the grain from the stalk.

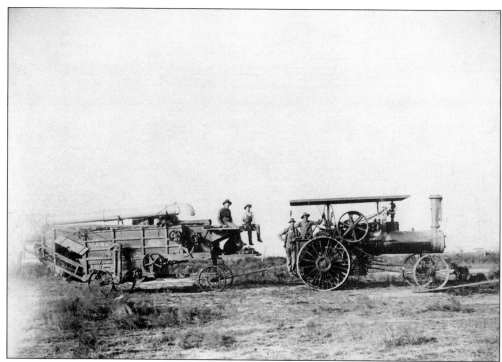

THRESHING MACHINE. Area farmers use a threshing machine in Markham. John Mikalson is standing with one hand on his hip.

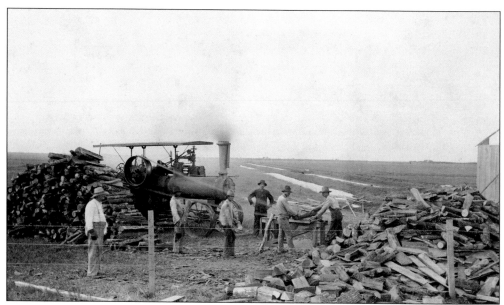

WOOD FOR AN ENGINE. Men chopped and split this wood that was used to fire the engine used to operate a rice threshing machine. John Mikalson is the man in black.

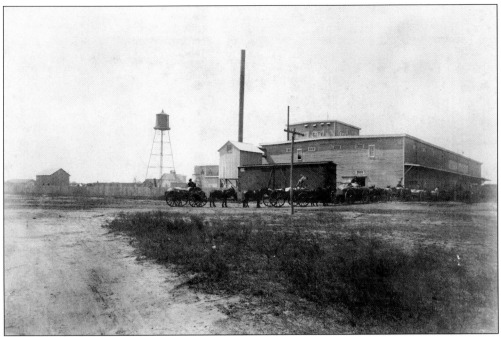

BAY CITY RICE MILL. In 1901, Henry Rugeley of Bay City, along with two other gentlemen from out of state, bought a block of land by the Cane Belt sidetracks for a rice mill. The warehouse was built first and was finished in August. It was two stories tall with offices, sample rooms, and a farmers' waiting room upstairs. The following year, the rice mill was erected.

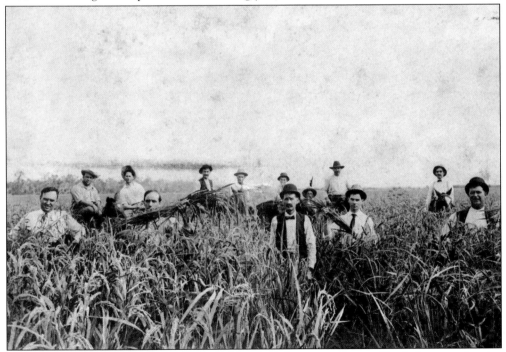

RICE FIELD. Along with the Burton D. Hurd Land Company, Burton Hurd also owned a rice farm in Collegeport. Around 1911, this field of rice produced an abundant crop.

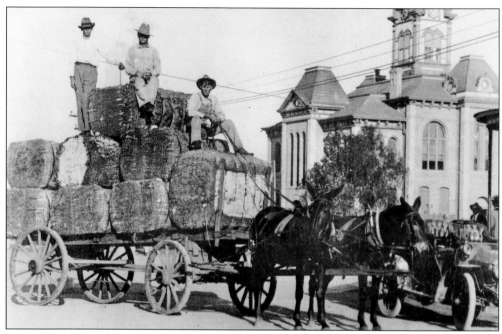

HAULING COTTON. After completing the exhausting work of stacking cotton bales, farm workers haul the cotton to market in mule-drawn buckboards. In the background is the original Matagorda County Courthouse, built in 1896. This courthouse was torn down to make room for a more modern courthouse in 1928.

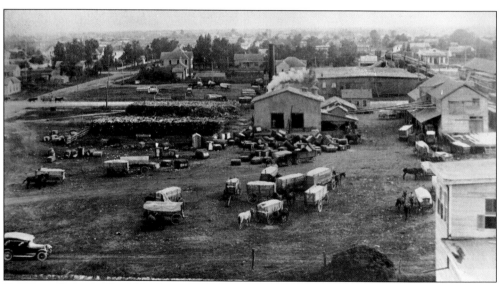

RUGELEY COTTON GIN. The James W. Rugeley Cotton Gin was situated on Seventh Street by the Santa Fe Railroad Depot in Bay City, Texas. It operated during the 1910s and 1920s, and was one of the first gins in the county. The gin's location is the present-day site of McDonald's.

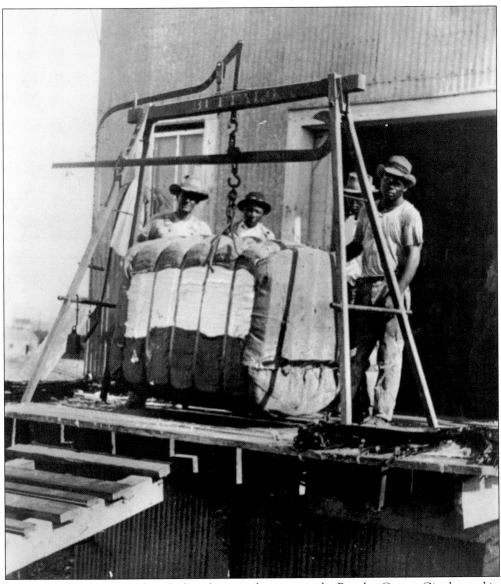

WEIGHING COTTON. Unidentified workers weigh cotton at the Rugeley Cotton Gin, located in Bay City, Texas. Professional photographer Lorenzo M. Huffman took this photograph in 1914.

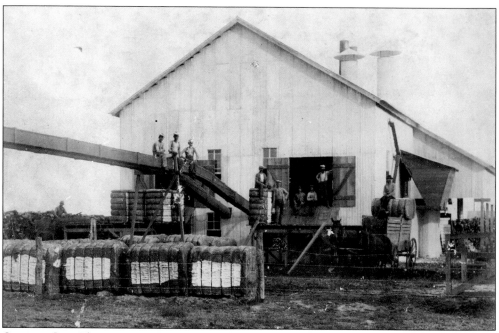

COTTON GIN. The cotton gin in Markham, Texas, serviced many area cotton farmers and helped make cotton one of the county's main crops in the early years.

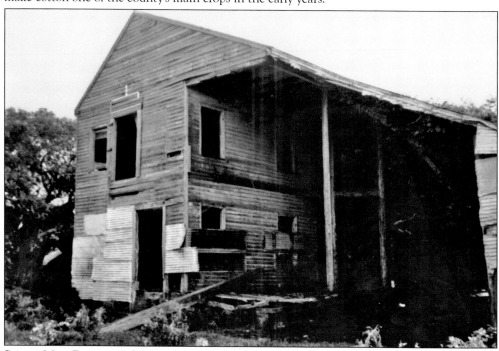

SUGAR MILL BARON. Col. James B. Hawkins built possibly the largest sugar mill in Texas during the mid-1800s in Hawkinsville. The Hawkinsville mill was made with kiln-dried brick that was made on the Hawkins Plantation by slave labor. After the Civil War, Colonel Hawkins turned his focus on the cattle business. Today the mill is in ruins. Shown here are the remains of the Hawkins home.

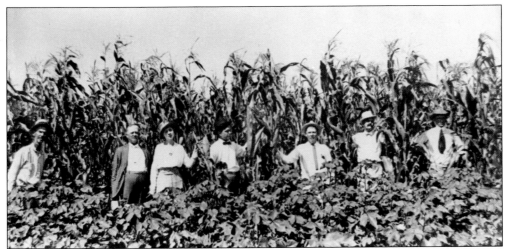

CORN CROPS. Farmers in Collegeport were hit hard between the years of 1914 and 1920 by numerous pitfalls. An incomplete canal system, exorbitant shipping fees, a freeze, and other downfalls took their toll on farmers and ranchers. Despite these hardships, at least one farmer was blessed with this successful corn crop in 1916.

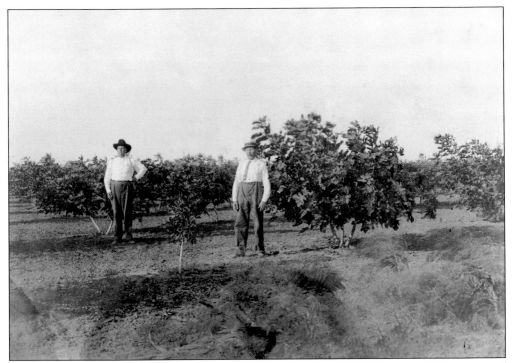

FIG ORCHARD. After farmers, ranchers, and businessmen left the Collegeport area because of the many hardships encountered, Dr. W. W. Van Wormer purchased empty lots and acreage in the area in 1925. He planted fig orchards that produced a delicious crop and continued to thrive until the Depression forced the Collegeport Packing House to close.

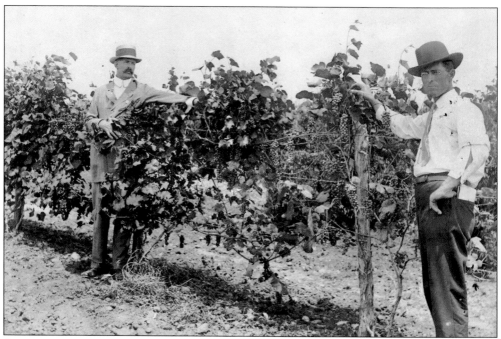

COASTAL VINEYARD. Early county residents tried their hands at growing grapes. It is not known why the venture was abandoned.

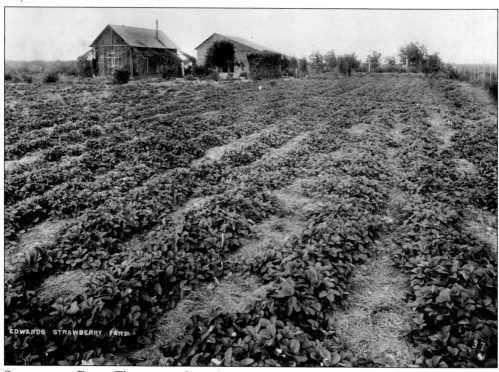

STRAWBERRY FARM. These rows of strawberries were planted on the Edwards strawberry farm in Collegeport. An advertisement in the *Collegeport Chronicle* on Thursday, November 2, 1911, promises "See Edward for strawberries."

PEACH ORCHARD. Much attention was paid to growing peaches in Palacios during the 1920s. This photograph shows one of several peach orchards located in this town at that time. A common phrase heard around the county was "delicious Palacios peaches."

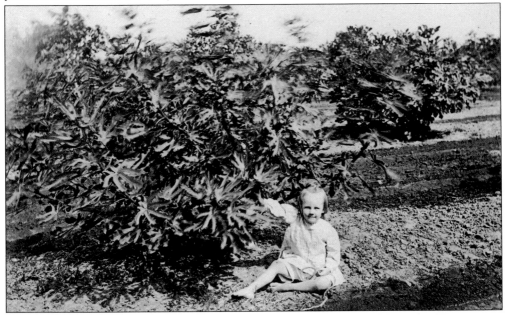

FIG TREE. Mary Elizabeth Cash posed beside one of the fig trees from this orchard in Bay City during the 1920s. The soil, rainfall, and climate in Matagorda County suited this crop. Even with the county's fig industry just beginning, three- to four-year-old orchards were averaging between $100 and $150 per acre.

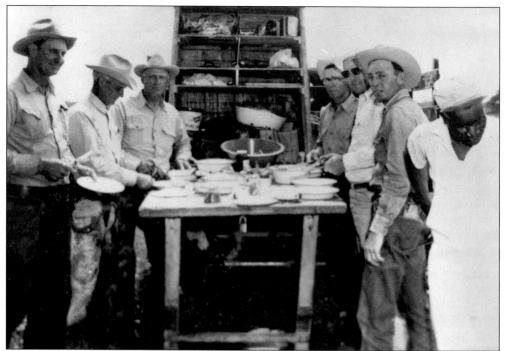

CHUCK WAGON. This chuck wagon was used on early cattle drives near Sargent, Texas. Ready to serve their plates, from left to right, are Leslie Chiles, Steve Perry, T. J. Poole Jr., Bart Morrow, two unidentified, and cook Sessia Wyche. Wyche's biscuits were known as a favorite among the cowboys. This photograph is from the 1920s.

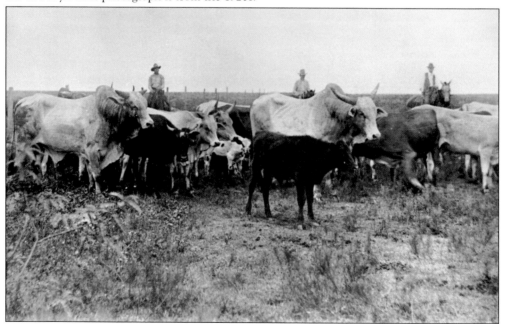

ROUNDUP. These three cowboys are rounding up a herd of cattle on the Pierce Ranch. Among the cattle are some Brahmas, which were well suited to this area. Professional photographer Lorenzo M. Huffman took this snapshot in 1915.

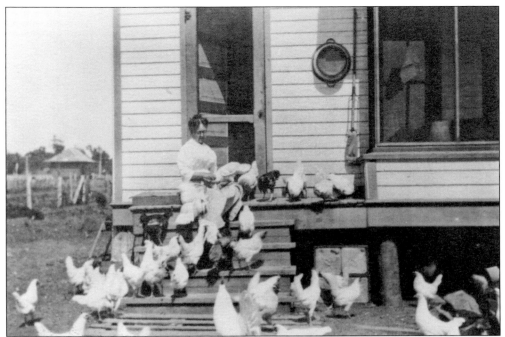

McMasters's Chickens. A Mrs. McMasters, whose husband was thought to have owned the general store, lets her chickens out of the chicken coop for feeding. Mrs. McMasters would sometimes sit on her back porch steps to feed her chickens.

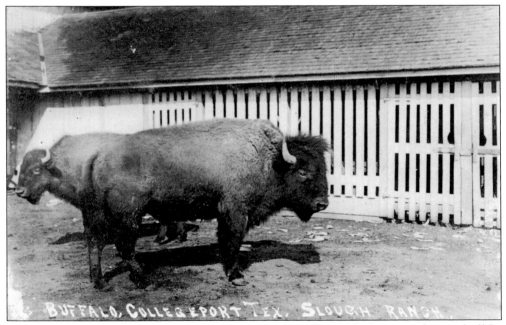

Buffalo. The Slough Ranch in Collegeport ventured briefly into the business of raising buffalo. The Slough Ranch was about 18 miles south of the Rancho Grande ranch.

GRIMES RANCH. The Bradford Grimes Ranch was located near the town of Tres Palacios. This photograph, taken in the 1860s, shows the home on the left and the canning building (or workers' quarters) on the right.

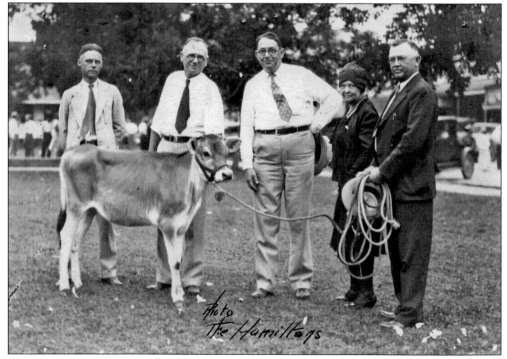

FIRST LIVESTOCK SHOW. The first livestock show in Matagorda County was held in 1938. This photograph, taken by the Hamiltons (a professional photography studio), shows the proud purchaser of a prize calf.

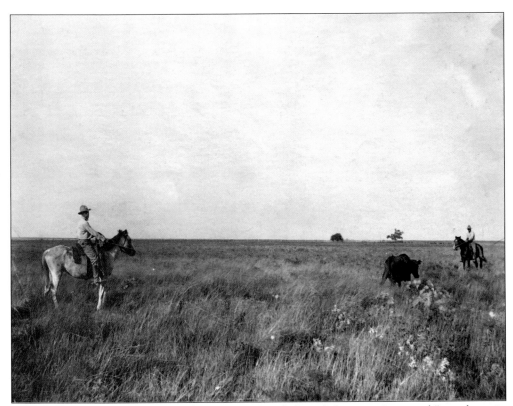

STRAY. These two cowboys round up a stray. It is believed the term "maverick" was born in Matagorda County after calves from a herd owned by a negligent Samuel Maverick swam from an island across to the mainland. When cowboys found such a calf, they were "Maverick's" but could be branded on the spot and taken into the new herd.

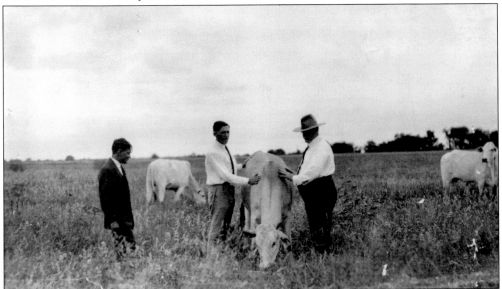

CATTLE INSPECTIONS. A rancher shows two visitors from Thailand an up-close view of part of his herd. These cattle were located on a Matagorda County ranch.

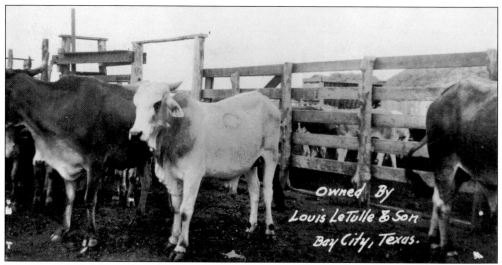

BRAHMA. This white Brahma bull was owned by Louis LeTulle and his son Samuel Victor LeTulle. This bull was classified as a prize bull around 1920. A few head of Brahmas first entered Matagorda County after the Civil War, brought by a few ranchers. Later, in 1906, the Pierce Ranch brought in the largest herd (51 head) ever imported into the United States.

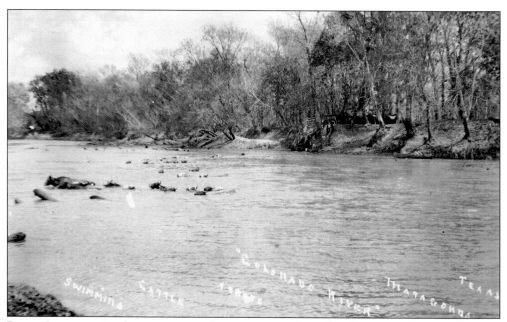

RIVER CROSSING. Cattle are maneuvered to swim across the Colorado River in Matagorda, Texas. Ranchers would move their cattle to the Matagorda Peninsula during the winter to graze on the salt grass. There was little worry they could stray because there was no land bridge to the area. In spring, they were herded back across the river to the mainland. This is a traditional practice that continues today.

Three

TEACHING OUR CHILDREN

EDUCATION IN MATAGORDA COUNTY

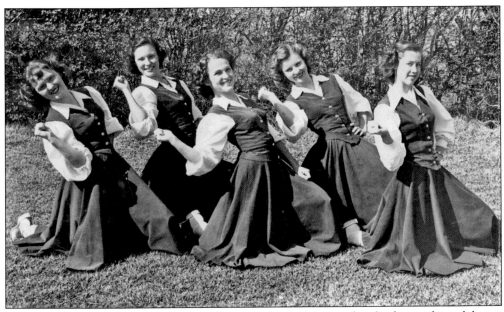

BLACKCAT CHEERLEADERS. The Bay City High School substitute cheerleaders performed during halftime at the Blackcat football game, allowing the other cheerleaders a break. The 1949 cheerleaders (from left to right) are Kathryn Treybig, Sidney Dierlam, Carol Kain, Joyce Brown, and Johnna Crow.

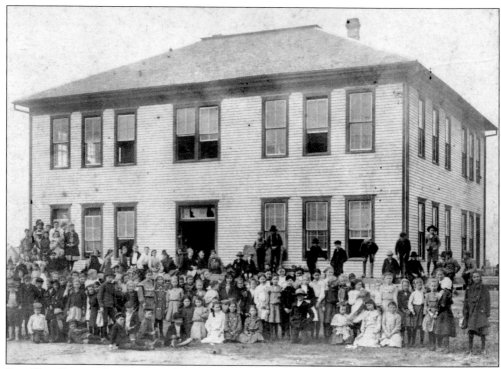

BAY CITY PUBLIC SCHOOL. Land for this structure was purchased in 1901 at the edge of the Bay City town site, an area that was considered "out in the country." A fence had to be built around the school to keep the livestock out. Considerably impressive for its time, this two-story building had eight separate rooms, halls, and cloak closets. The school was moved in 1905 to the north end of town for the African American children. They used this building, which became known as the Booker T. Washington School, until 1948.

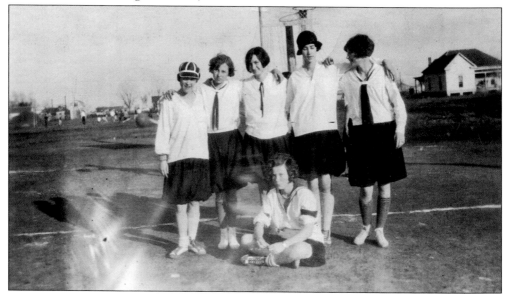

GIRLS' BASKETBALL TEAM. Keye Ingram coached the Bay City Blackcats girls' basketball players in the 1920s. Their uniforms resemble those worn in 1915.

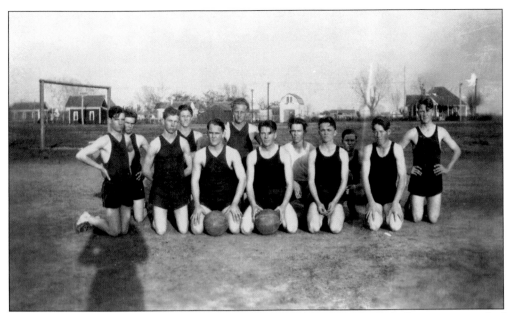

BLACKCAT BASKETBALL TEAM. The 1930 Bay City Blackcat boys' basketball team consisted of 12 dedicated players.

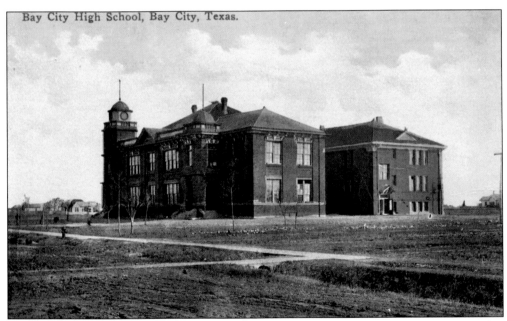

JEFFERSON DAVIS SCHOOL. In 1904, the cornerstone for a third school building was laid at Avenue L and Fourth Street in Bay City. This two-story brick structure was completed in 1905 and served children from the elementary division through high school. It included an auditorium that seated 450 people. By 1907, there were 185 students in attendance. In 1912, an addition to the brick school building was built, and 34 seniors graduated from high school.

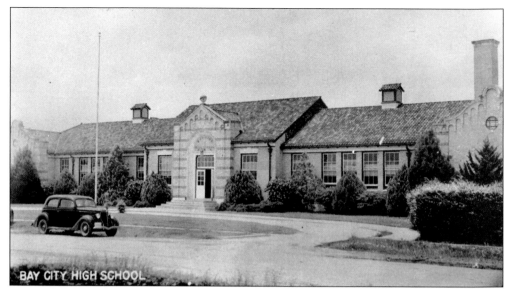

BAY CITY HIGH SCHOOL. Erection of this building began in 1929 and was completed in 1930. It was considered an ultra-modern building from the foundation to the top of the tile roof, with no conveniences or necessities left out. It welcomed 300 high school students in September 1930. In 1938, Matagorda and Gulf students were transferred to the high school, which resulted in an addition of three rooms and a study hall to the west wing of the building. It served Bay City as the high school until 1949, when it became Bay City Junior High and eventually Cherry Elementary School. The structure was demolished in 1986. The site received a marker in 1986.

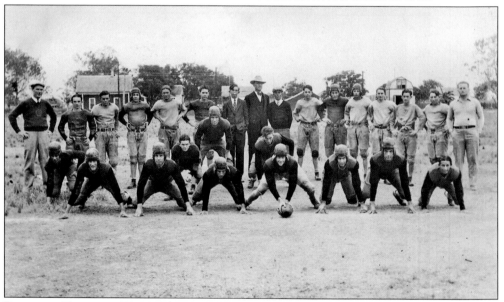

BLACKCAT FOOTBALL TEAM. The 1929 Bay City Blackcat football team included, from left to right, (first row) five unidentified, Ted Mangum, and Vernon Vandiver; (second row, backfield) unidentified, Victor Collins, unidentified, and Brooksy Smith; (third row) Furman D. Ray, Pete Kogutt, Kenneth Gordan, Harold Amos, two unidentified, Bert Carr, E. O. Hutcheson, Beal McKelvy, D. R. Chapman, Charles McGlaun, Forrest Bess, Joe Fryou, Norris Pier, Glen White, and Earl Meharg.

34

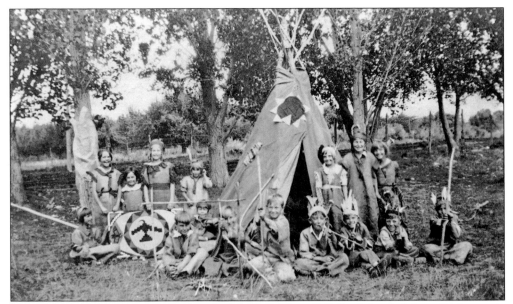

SCHOOL PAGEANT. County school superintendent Claire F. Pollard decided that all Matagorda County schools would combine for a program preceding promotional certificate exercises in 1924. The program represented the history and industry of the county and was held at the Baptist Young People's Union campground in Palacios. The first part of the program was a pageant representing the landing of La Salle. In this photograph, children dressed as Native Americans pose in front of their tepee while waiting on La Salle.

TENIE HOLMES KINDERGARTEN HOUSE. This folk Victorian–style home, located at 2520 Avenue H, was constructed in 1908. It was owned by several families until it was purchased by "Miss Tenie" Holmes in 1936 for the purpose of a kindergarten, where she taught for many years. The house was acquired by the Bay City Independent School District in 1941, and Holmes taught until her death in 1952. Virginia Peden bought the house and continued teaching kindergarten there until 1975.

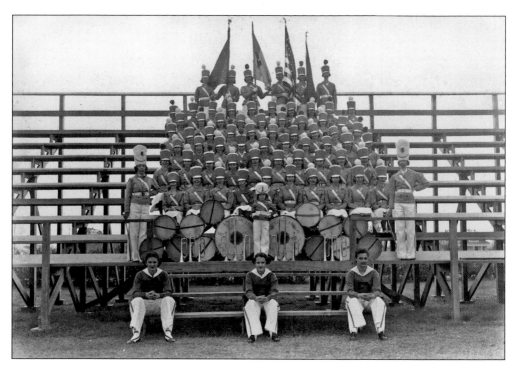

PEP SQUAD (1934) AND KEYE'S KADETS AND CHEERLEADERS (1937). The Bay City School Pep Squad and Keye's Kadets were one and the same, and were sponsored all but one year by Keye Ingram. American Legion members Sam Selkirk and Zac DeLano assisted, and the American Legion furnished drums and bugles. The organization originated in 1924 as the Pep Squad. Membership was open to all girls in school regardless of age because the entire school system was under one roof. Because of membership growth, age restrictions were changed to include only 6th-grade through 11th-grade girls, and finally in 1930, it was open only to high school girls. In 1934, the members changed their name to the Blue Cadets. By the fall, it was renamed again in honor of Keye Morgan Ingram. The group performed at football games, parades, and other special occasions until 1941. Pictured above from left to right are (first row, seated) cheerleaders M. A. Davant, M. J. Sisk, and M. A. Horn; (second row, standing) drill major Billie Bell, mascot Beatrice Simon, and drum major Dorothy Loos.

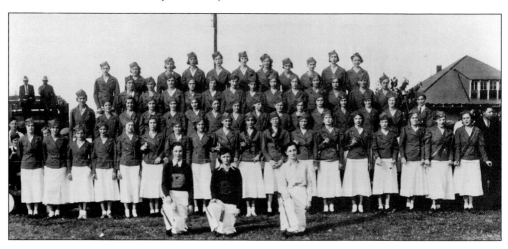

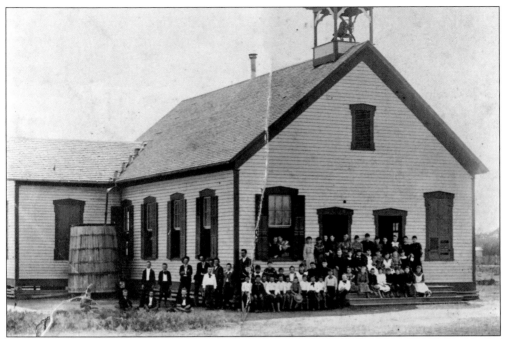

MATAGORDA PUBLIC SCHOOL. This school building, constructed of cypress wood, was erected in 1888 on the corner of Cedar and Lewis Streets. Primary grades through high school were all taught here. By 1909, the younger children attended another school, and higher grades continued their education at this location. School was taught here until 1914, when a new brick school was built. The old building was moved to Lewis and Mulberry Streets, where it remains as the Friloux residence.

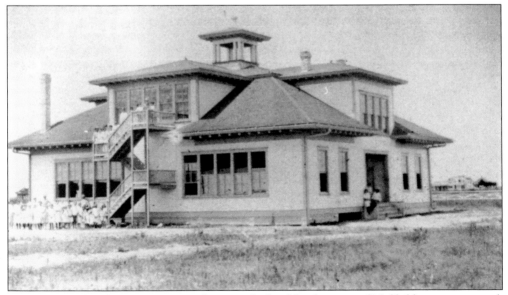

MIDFIELD PUBLIC SCHOOL. In 1911, the second school for the town of Midfield was constructed. The original building consisted of only two rooms but was later enlarged to include four classrooms and an auditorium on the second floor. It was destroyed by a fire in 1929. The damaged building was replaced, but it is no longer in use.

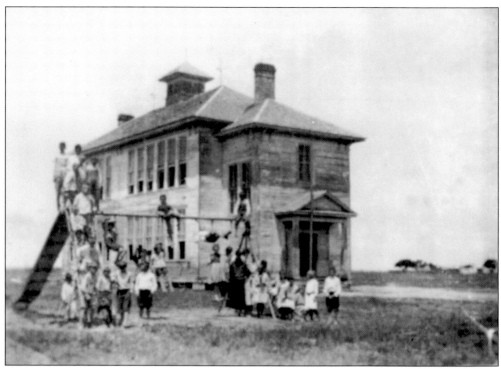

WADSWORTH SCHOOL. In 1913, land was purchased in Wadsworth, Texas, for a public school where first grade through high school students would be taught. The large, two-story, wooden building had two large classrooms downstairs and one large room with a stage upstairs. There was no indoor plumbing. Later the school was changed to a primary school, and the secondary students were bused to Gulf High School. It was used until 1940, when all students were bused to Bay City.

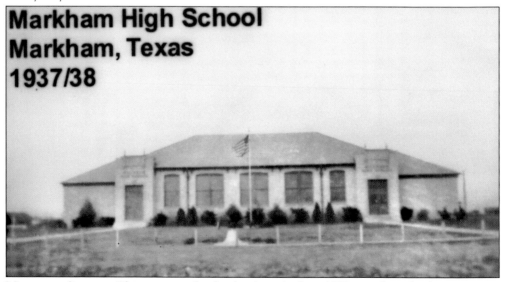

MARKHAM SCHOOL. This one-story brick school was built in 1935 to replace the first two-story wooden school in Markham. It has since had several additions and is still standing. The bell, which is displayed in the schoolyard, was removed from the top of the first school.

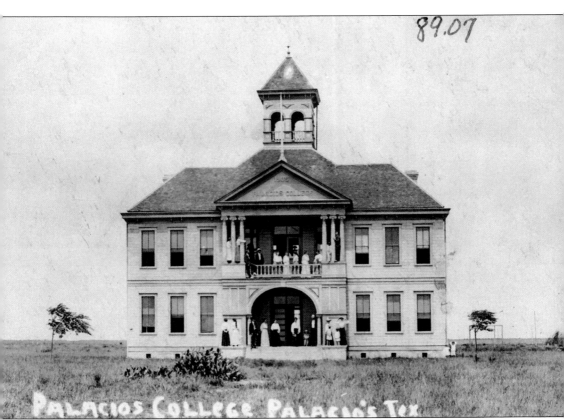

PALACIOS BAPTIST COLLEGE. It was the desire of Rev. W. H. Travis, who arrived in Palacios in 1905, to organize a school that would educate young men and women who would work their way through school by raising vegetables on school lands. By 1907, Palacios Baptist College was a reality. It struggled financially, but by 1913, it had 103 students. The school closed in 1917 because young men were going to war instead of school. It served as a Baptist home for elderly ministers from 1918 to 1921 but closed because of operating costs. It later became private property, and a girls' dormitory (added in 1910) was moved to the Palacios Baptist Encampment.

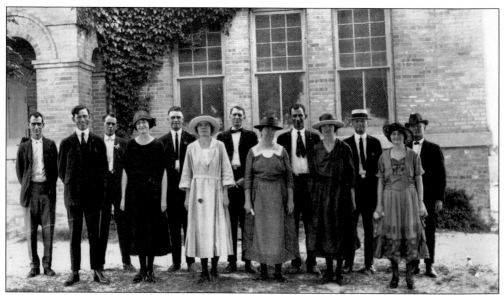

BLESSING SCHOOL STAFF. Teachers and school board members from Blessing pose in front of the school for this picture, taken in 1921. From left to right are (first row) Superintendent Ralph Newsom and teachers Francis Harrison, Mary Doss, America Judkins, Beth Wynn, and Mary Luder. The second row consists of unidentified school board members.

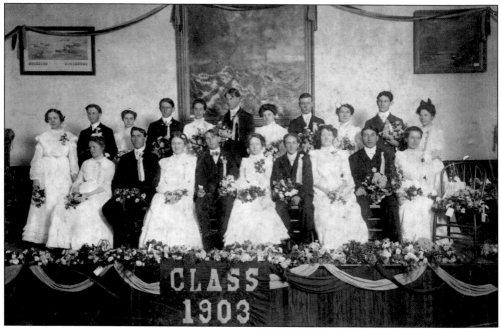

BLESSING GRADUATES. Students of the 1903 Blessing senior class pose for their group graduation photograph. Mrs. H. L. (Olpha) Brown was the first teacher.

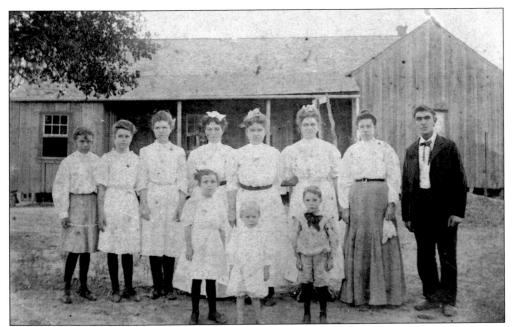

EARLY BLESSING SCHOOL. This photograph shows teachers and students in front of an early Blessing School. In 1948, school districts in Ashby, Midfield, El Maton, Blessing, Buckeye, Clemville, and Markham merged to become the Tidehaven Independent School District.

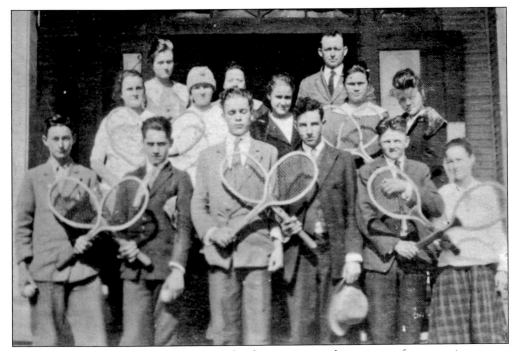

BLESSING TENNIS TEAM. The Blessing School tennis team takes time out from practice to pose for a photograph. L. D. Midgett, standing on the far right in the back row, coached them. He was employed as a Blessing teacher from 1913 to 1915.

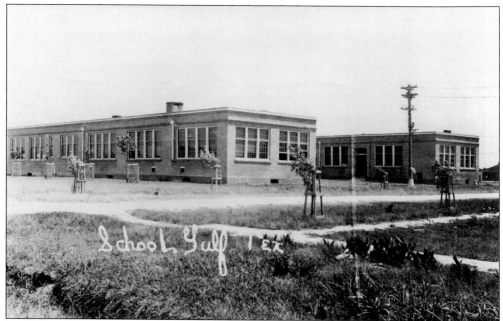

GULF SCHOOL. A modern brick school was built by the Gulf Independent School District, which had been organized by the citizens in the town created and owned by the Texas Gulf Sulphur Company. Primary through high school grades were taught there. Students from surrounding areas also attended classes at this school.

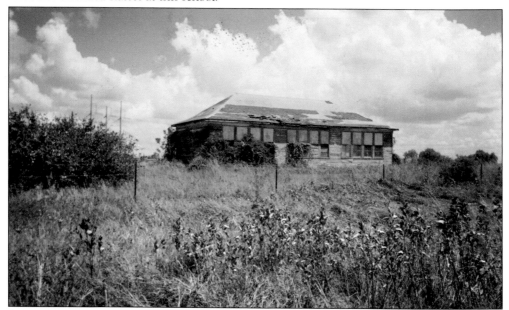

PRAIRIE CENTER SCHOOL. A new three-room schoolhouse was completed in 1917. It was the second school for the Common School District No. 12, which was organized between Tres Palacios River and Cash's Creek in 1912. In the 1930s, the book and storage room was converted to accommodate indoor plumbing. The school closed in 1945, and the building served as a community center. In 1955, it was deeded to the Prairie Center Home Demonstration Club and given a new roof, but it lost its original cupola and chimneys in the process.

Four

BEAUTIFUL BUILDINGS
STRUCTURES IN THE COUNTY

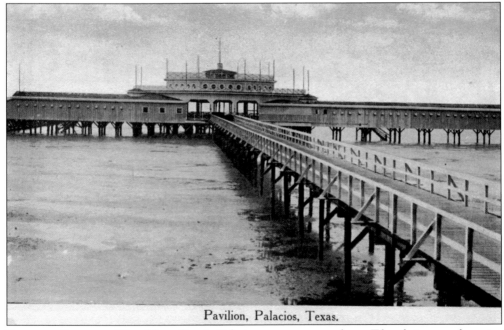

Pavilion, Palacios, Texas.

PALACIOS PAVILION. The old pavilion in Palacios was constructed on a T-head pier over the water at the south end of Pavilion Street. Bathhouses were located on the pavilion for swimmers. The pavilion was the location of much entertainment, including dances, skating, fishing, games of dominoes, and picnics. Damaged by previous storms, the structure was demolished in 1935 to make way for a new one.

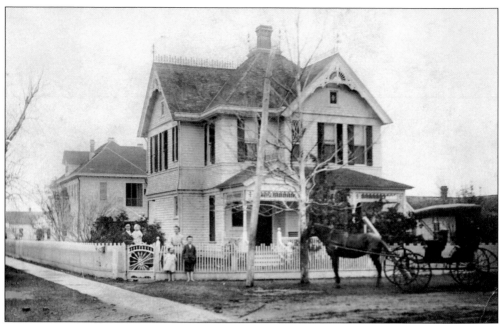

Magill/Cash Home. This structure was erected in 1903 by G. M. Magill and in 1909 was bought by William Cash. The two-story wood-frame Victorian structure has a gable roof, flared second floor, column porch, and some stained glass. It now serves as the Bay City Funeral Home at 2205 Avenue K.

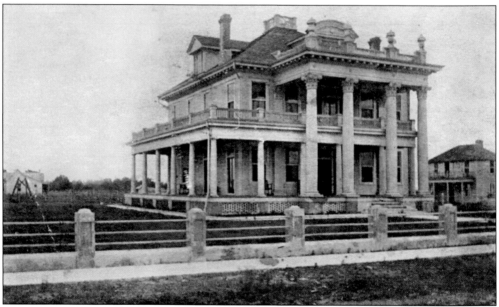

Gaines/Rugeley/Letulle Home. This home, located at 2116 Matthews Street in Bay City, is still standing today. The three-story, five-bay, wood-frame Classical Revival–style residence was built in 1910. The hipped-roof, two-story Corinthian columns, and five fireplaces are features that add to its beauty. A sophisticated feature for its era was an inner communication system built between the master bedroom and kitchen. The third floor was the ballroom. An observatory at the top provided a bird's-eye view of the town.

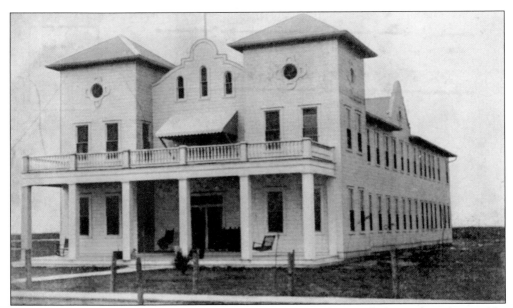

HOTEL BLESSING. Constructed in 1906 in Blessing, Texas, the Hotel Blessing was designed by well-known architect Jules Leffland. It was built by developer Jonathan E. Pierce, who lived there until his death in 1915, and served many people while they were searching for land to build homes. It is now owned by the Blessing Historical Foundation and continues to operate as a hotel, coffee shop, and restaurant. It is on the National Register of Historic Places and received a Recorded Texas Historical Landmark in 1965.

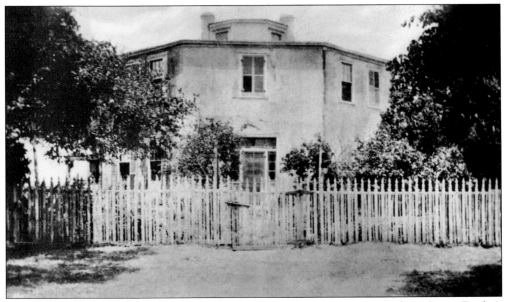

TADMOR. Built in 1855 by the Robbins family, Tadmor's inspiration came from Orson Fowler's *A Home for All*. The octagon-shaped home was constructed of water, lime, sand, and gravel, which rendered the house both rodent-proof and fireproof. Shell was hauled in by boat and then burned to make the lime. During the Civil War, it was mistaken for a fort and was fired upon; cannonballs are said to have lodged in its 18-inch-thick walls. It was abandoned in 1938 for a new house and succumbed to ruins.

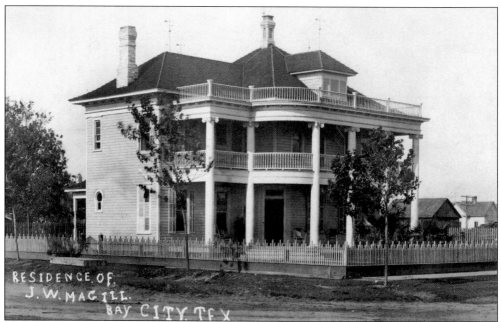

MAGILL/POOLE HOME. This home was erected in 1904 for early Bay City developer G. W. Magill. In 1915, Thomas and Jessie Poole purchased the house, and it still remains in the Poole family today. Located at 2201 Fifth Street, this building is an example of the Classical Revival style.

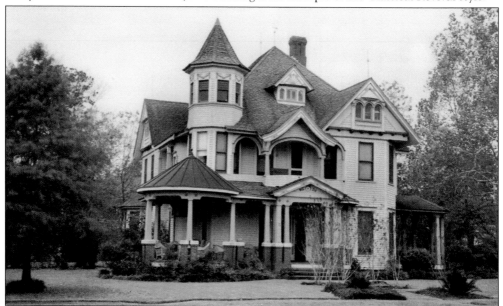

HOLMAN HOME. Construction began on this Queen Anne/Victorian house in 1908 and was completed in 1909 at 2504 Avenue K in Bay City, Texas. It has asymmetrical composition, an elaborate roof, and wraparound porch. The corner tower has a copper roof on the first level and shingles at the second level. It served as a home to Spanish-American War veteran and county judge William Holman and his wife from 1908 to 1914 and remained in the Holman family until 1978. Then it was purchased by James and Judith Allen and is now the residence of David and Renee Johs. It received a Recorded Texas Historical Landmark in 1994.

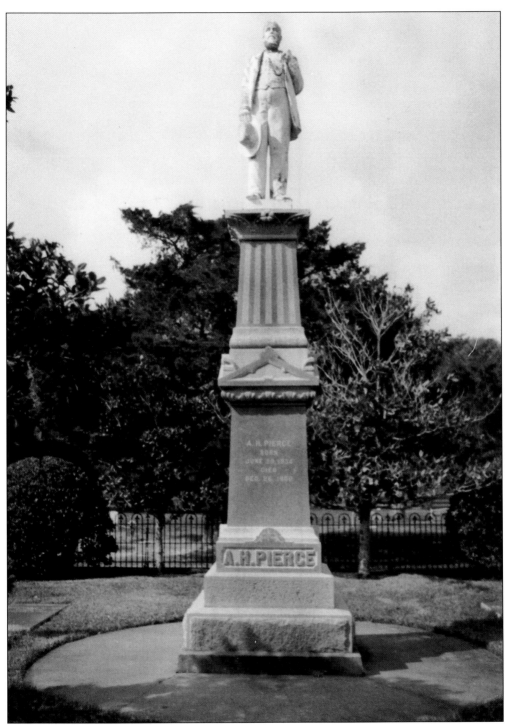

A. H. Pierce Monument. This 40-foot-tall white marble statue of Abel H. "Shanghai" Pierce is located at Hawley Cemetery in the Deming's Bridge community. A beautiful iron fence surrounds the monument and grave. Pierce, a great Texas rancher and trail driver, paid $10,000 and had it erected several years before his death in 1900.

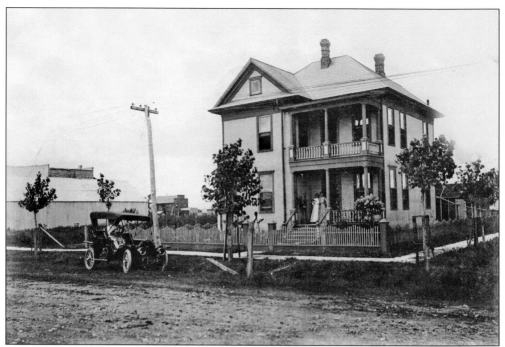

GAEDKE HOME. This two-story structure was the home of an early Bay City dentist, Dr. H. E. Gaedke. Homes were built with porches and many windows to take advantage of the coastal breeze.

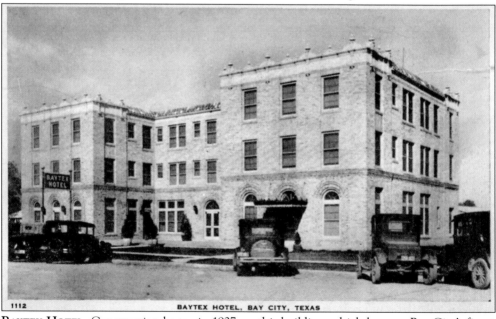

BAYTEX HOTEL. Construction began in 1927 on this building, which became Bay City's finest hotel. The Baytex hosted many social events and business meetings throughout its heyday. In 1934, the chamber of commerce regularly met there on the first Tuesday of each month, and the first Rice Festival tea was held in the hotel in the fall of 1941. Although there has been interest shown in restoring the building, it is currently in disrepair, with the interior gutted and broken-out windows.

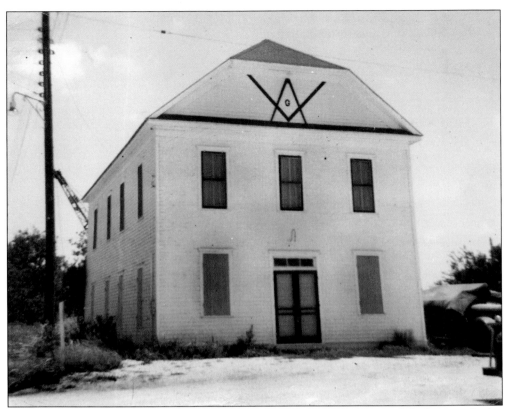

MASONIC LODGE NO. 411. Jonathan Pierce and the Masonic brothers erected the Masonic Lodge in 1875 near the Pierce Ranch at Deming's Bridge. The first floor served as a Baptist church and community center. It was moved to Blessing, Texas, around 1903, shortly after the town was established. There the ground floor housed the first school and also was used for community functions until a community center was built. The lodge is still active today. It received a Recorded Texas Historical Landmark in 1965.

A. B. PIERCE HOME. This three-story house with a basement was built in 1909 for Abel B. Pierce, one of the founders of Blessing, Texas. Area civic leaders gathered at this home many times, and the Right Reverend C. S. Quin, an Episcopal bishop from the Diocese of Texas, often visited here. Abel's wife, Adelade, founded the Matagorda County Federation of Women's Clubs in this home in 1916. It remains in the Pierce family today and received a Recorded Texas Historic Landmark in 1968.

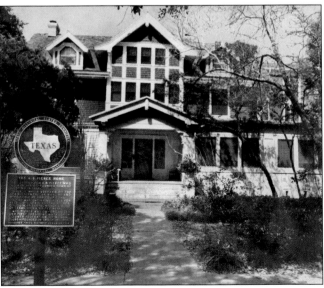

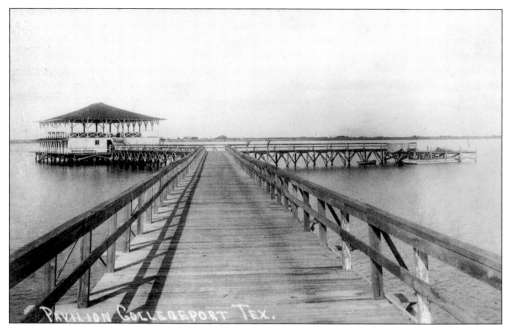

COLLEGEPORT PAVILION. The pavilion in Collegeport was already built when the grand opening of the town was held on May 25, 1909. The pier and pavilion were located across from Central Street.

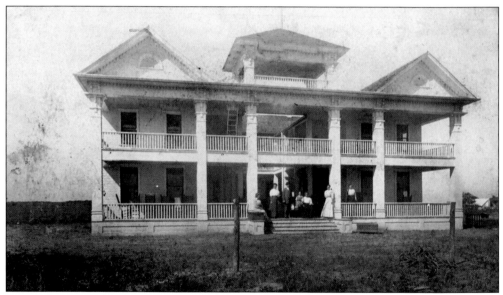

HOTEL COLLEGEPORT. A hotel that could accommodate 100 people was erected around 1908 on the north side of Central Street, facing Tres Palacios Bay and the Collegeport Pavilion. Advertisements claimed it was a model resort hotel and a health and pleasure resort. On May 25, 1909, the town's grand opening was held here. Large groups searching for land on which to build would gather here. Clarence T. Doman bought and demolished the hotel in the 1920s and used the lumber to build a new house.

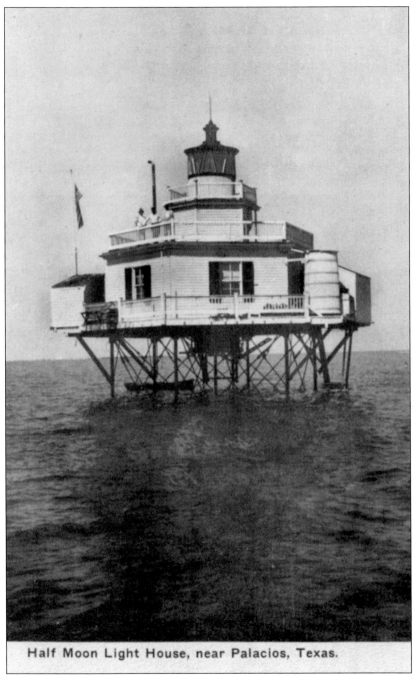

Half Moon Light House, near Palacios, Texas.

LIGHTHOUSE. Half Moon Reef Lighthouse construction began in 1854 at the southern end of Half Moon Reef and was completed in 1858. The structure was made of cypress wood erected on iron pilings. The white light atop was visible from six miles away. In 1935, a new eight-day portable kerosene brass light was installed. Eventually, there were a total of 21 lights at Half Moon Reef. After a fierce storm, the structure was condemned in 1942. The lighthouse was removed, and in 1980, it was restored by Michael Crain, a 15-year-old Boy Scout from Olivia, Texas. Today the building stands next to the Port Lavaca Chamber of Commerce and serves as a visitors' center.

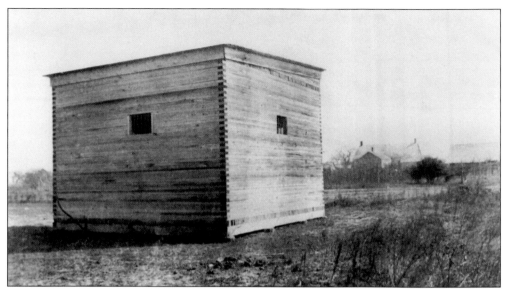

MATAGORDA JAIL. William Dunbar built this jailhouse in Matagorda, Texas. He was paid $500 in $20 gold pieces for his efforts.

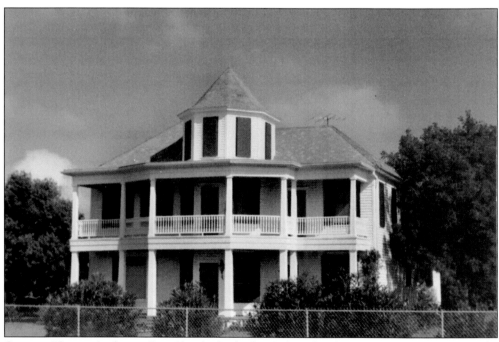

CULVER HOME. Architect Roy Shoultz built the Colonial-style two-story house in 1902 for George B. Culver, a pioneer of the Intracoastal Canal. It has two large galleries and a cupola. It was constructed out of pine and cypress, and the fireplace tile was imported from England. Statesmen, railroad men, and church leaders were among the distinguished guests who visited the home. It received a Recorded Texas Historic Landmark in 1967.

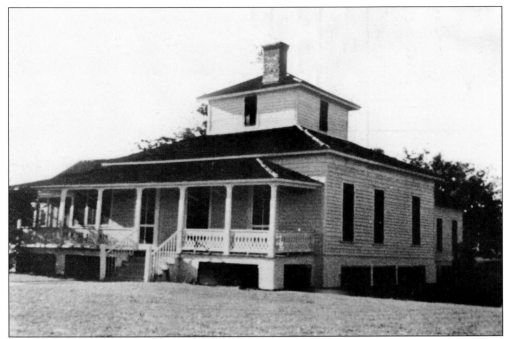

FISHER/HAMILTON/BURKHART HOME. Construction on this two-story wooden structure was begun in 1833 by Samuel Rhoades Fisher and was completed in 1839. This smaller version of Greek Revival architecture was quite different for Matagorda County. T. J. Hamilton later acquired the home, and in 1859, it was purchased by Charles Burkhart.

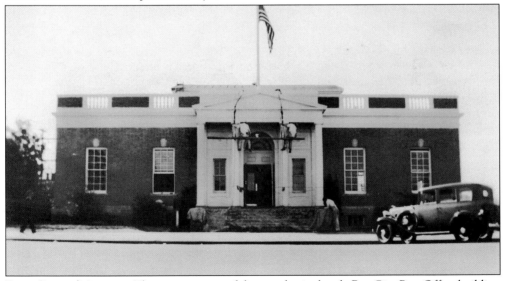

POST OFFICE/MUSEUM. The construction of the neoclassical-style Bay City Post Office building began in the spring of 1917 and was completed in May 1918. A south wing was added in 1958, and minor interior changes were made. It served as the post office for 71 years. Throughout the years, it served as the town meeting place, the site of the Selective Service Board, a fallout shelter during the cold war, and a shelter during hurricanes. The post office moved to a new building in 1989. The Matagorda County Museum Association bought the building in 1990 and opened it as a museum in 1992. It received a historical landmark designation in 1992.

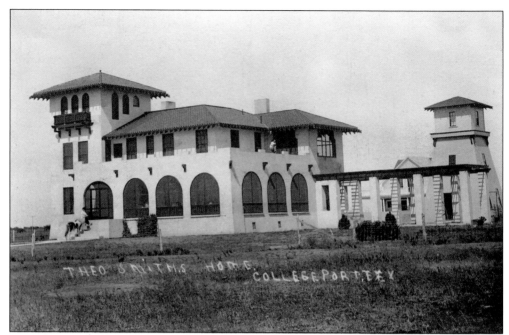

THEO SMITH HOME. This home, built in Collegeport around 1910, was located on Bayshore Drive. It was the home of Theo Smith (who sold hardware, lumber, and implements) and his family. It is one of the few well-preserved homes still standing in Collegeport today. It is now owned by Frank Canfield of Houston.

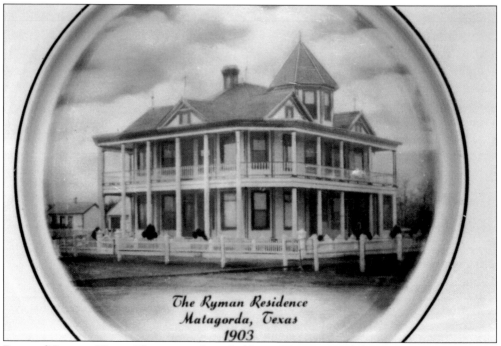

RYMAN/HAVARD HOME. This two-and-one-half-story Victorian-style house was erected in 1902 in Matagorda, Texas. It features columned, L-shaped, wraparound, balustrade galleries on the second floor, stained glass in the main windows, and fish-scale shingles on the gables.

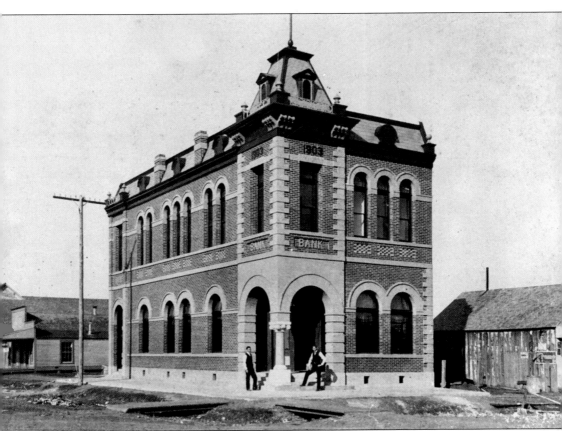

BAY CITY BANK. This building was erected in 1903 at 2044 Avenue F in Bay City, Texas, under the supervision of well-known architect Jules Leffland. The two-story structure was made of stone and masonry, and is considered a Second Empire design. Its mansard tower, arched bays, and corner entry add appeal to the bank building. It underwent few changes throughout its life and remains in good shape today. It received a Recorded Texas Historical Landmark in 1965.

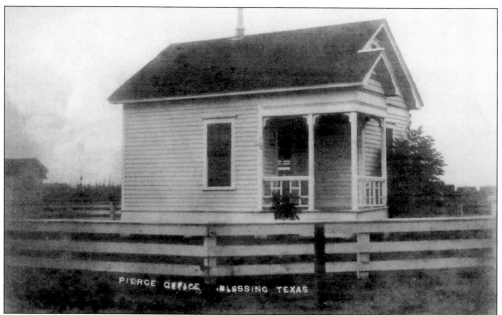

PIERCE OFFICE. This building was originally the business office at Rancho Grande (the Pierce brothers' ranch headquarters), where Shanghai and Jonathan Pierce were partners with Allen and Tom Poole. It was moved to Blessing, Texas, in 1872 and became A. B. Pierce's office and the Blessing State Bank. In 1915, it was moved to the town square to become the Blessing Library. It is now located on the north side of the community center.

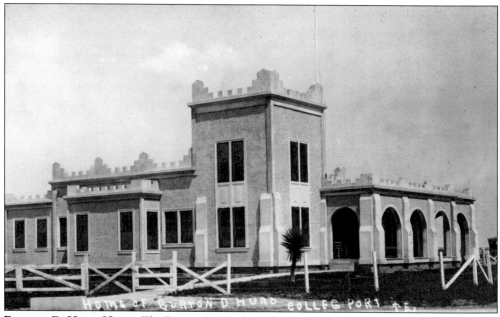

BURTON D. HURD HOME. The Burton D. Hurd Land Company founded the town of Collegeport on May 25, 1908. Around 1910, Burton Hurd had this home built for his family in Collegeport on Bayshore Drive. The Woman's Club was organized in this home on May 19, 1910, by Dena Hurd. The Hurds resided in this home until their deaths in the late 1930s. Mrs. Dompier of Houston, the daughter of R. E. and Vivian Smith, is the present owner.

Five

A STEP BACK IN TIME
STREET SCENES FROM
MATAGORDA COUNTY COMMUNITIES

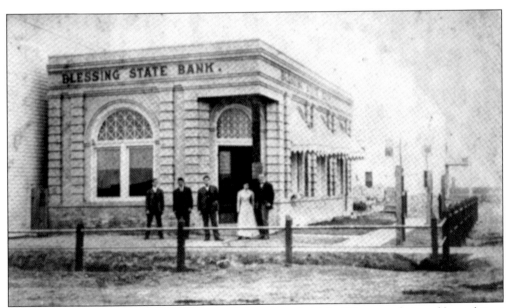

BLESSING STATE BANK. This classic early-20th-century brick building was designed by architect Jules Leffland. The bank was erected in 1907 in Blessing, Texas. The owner and president, J. E. Pierce, had a capital stock of $10,000. The bank managed to continue operations in the beginning of the Depression but ceased operations in 1932. Blessing was without a bank until 1996, when the building was restored and reopened as a bank. It received a Recorded Texas Historical Landmark in 1997.

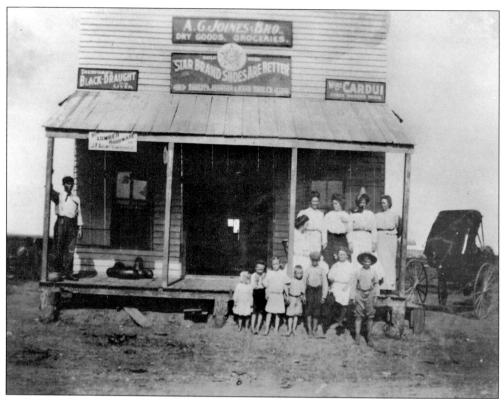

A. G. JOINES AND BROTHERS. A. G. Joines and Brothers was a dry goods and grocery store that serviced the Wadsworth, Texas, area in the early 1900s. Since traveling to the next town was an all-day affair, it was imperative that each small community have its own general store.

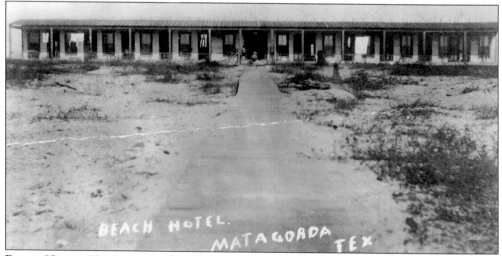

BEACH HOTEL. The Beach Hotel in Matagorda, Texas, provided respite for families trying to get away from the heat of the city and enjoy the cool gulf breezes. This hotel no longer exists; it is not known what caused its demise.

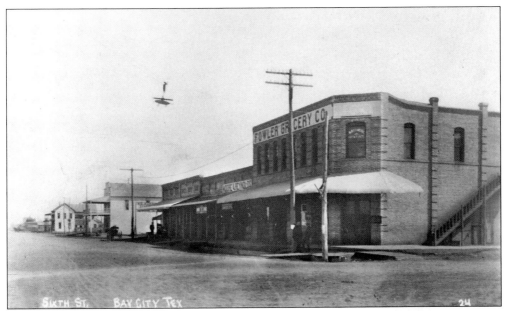

A 1904 BAY CITY STREET SCENE. This photograph, taken in 1904, gives a glimpse of what one saw looking north on Avenue G in Bay City. The Fowler Grocery Company on the far right was at the corner of Avenue G and Sixth Street.

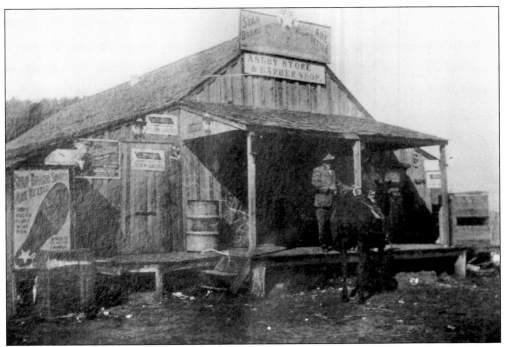

ASHBY STORE. A general store was established in 1890 by Capt. W. W. Moore by the Wilson and Tres Palacios Creeks on the west side of the Colorado River. A barbershop was included inside the store. This was the beginning of the Ashby community, named after Captain Moore's commanding officer in the Terry's Texas Rangers. Boats navigating the Tres Palacios as far inland as Deming's Bridge would stop at this store for supplies.

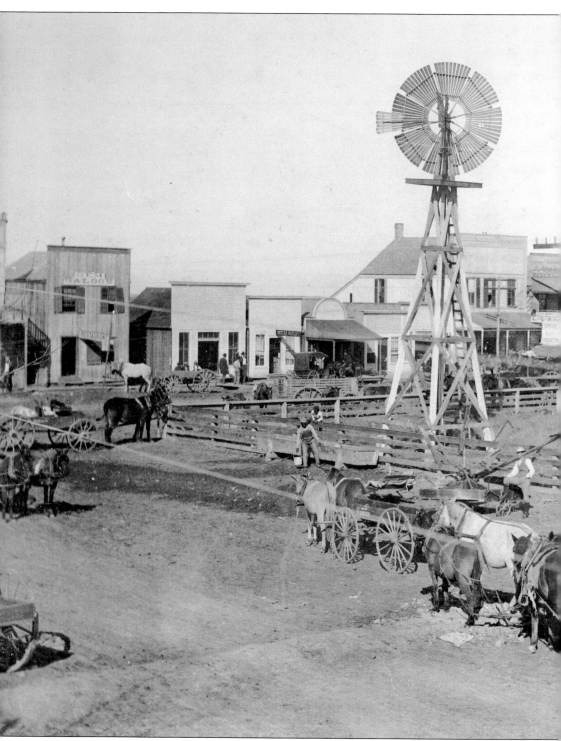

DOWNTOWN SQUARE. In 1898, the north side of Bay City's downtown square included the Rowlett House, the Gem Saloon, an ice cream parlor, a saddle shop, the LeTulle Mercantile Company, the Wholesale Grain and M. Products Office, the Bay City Irrigation, the Wagon, Shulehesk

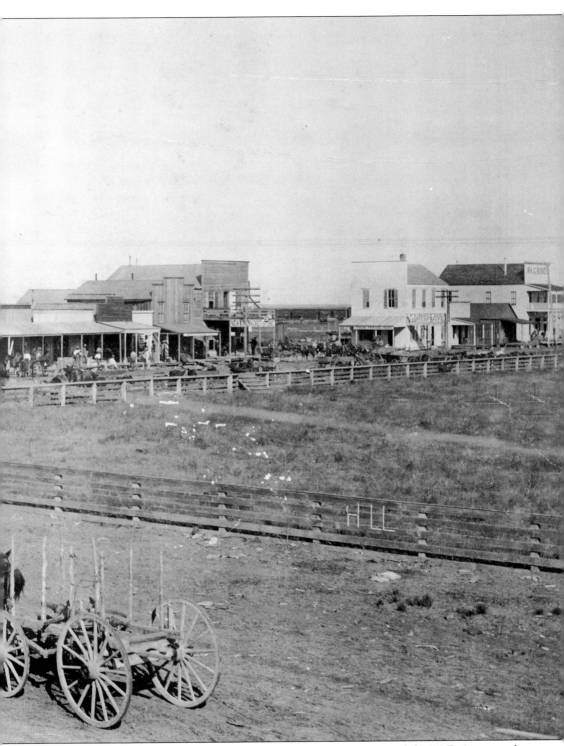

Fuel, the New Racket Store, an outhouse, the Tribune Printing House, and the W. E. Austin and Company. The courthouse is just out of view on the right side of the photograph.

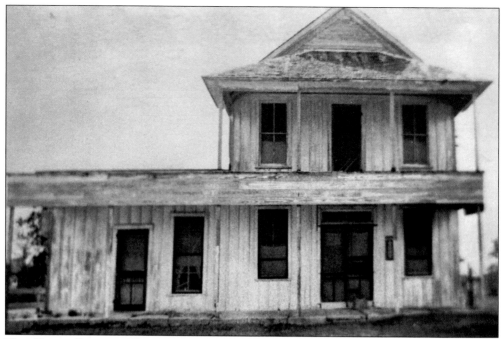

VAN VLECK SALOON. This two-story building was located in Van Vleck, Texas. In 1901, it operated as a saloon and later became the home of Octavia Scoggins.

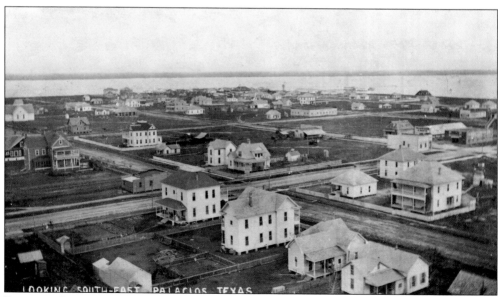

PALACIOS STREET SCENE. This aerial shot was taken in 1913 and looks southeast in Palacios, Texas. In the background, one can see the south bay front.

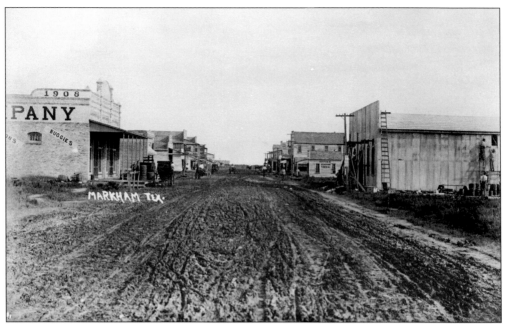

MARKHAM STREET SCENE. This is an early street scene of the main thoroughfare in Markham, Texas. As seen in the photograph, the roads were made only of dirt. They remained unpaved until 1965.

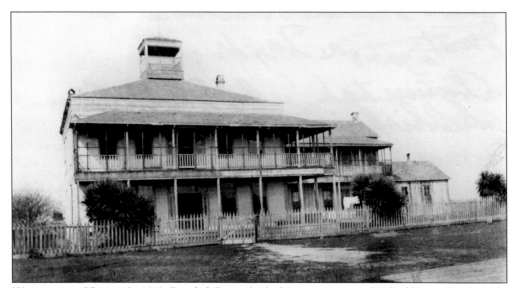

WADSWORTH HOTEL. In 1912, Zepplick Butter built this two-story wooden building in Wadsworth, Texas. The community used the lower floor for meetings and special events. The upper floor served as a hotel, and guests could get a hot bath for 25¢. It stood empty from 1923 to 1932, when Frank Culver purchased and demolished the building for the wood.

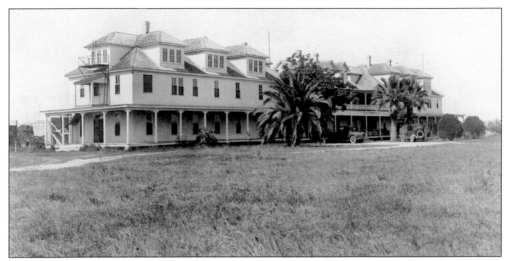

PALACIOS HOTEL. Among the first buildings to be constructed in Palacios, Texas, was the Bay View Hotel. It was erected in 1903 and faced the East Bay. Architect Jules Leffland designed this two-and-a-half-story building with a three-part mass, each with a hip roof and dormers. It was built with materials from Louisiana and consisted of yellow pine for the frame, cypress for the siding, and 18-inch shingles for the roof. In 1905, it was sectioned into three parts, the original porch and chimney were removed, and it was moved to the South Bay. Additional wings and a 400-foot porch were added; the porch was considered the longest in Texas and often held performances by the Palacios Marine Band. It later became known as the Palacios Hotel. The hotel has withstood hurricanes and one fire, and has gone through many changes in ownership, renovations, and improvements. It received a Registered Texas Historic Landmark in 1965.

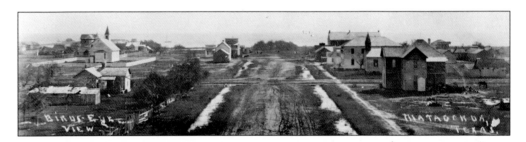

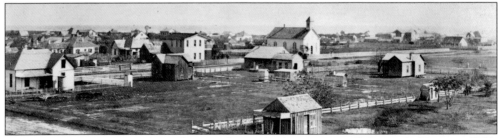

MATAGORDA TOWN SITE. These photographs give bird's-eye views of Matagorda, Texas, in 1908. It shows the back of the historical Christ Episcopal Church at the top and a front and side view of the church at the bottom.

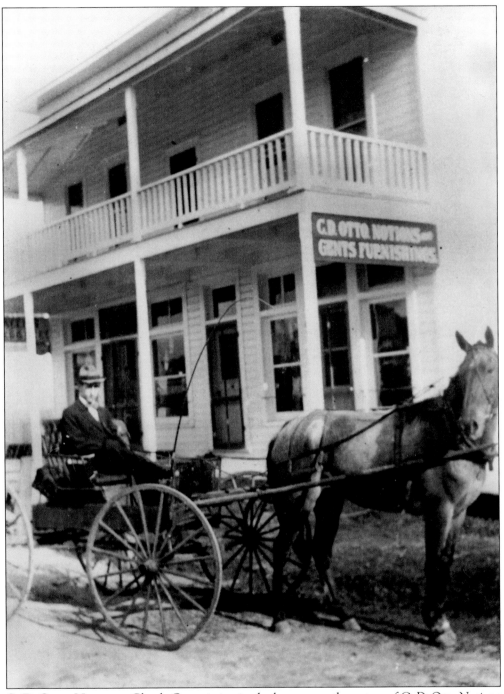

C. D. Otto Notions. Claude Otto, sitting in the buggy, was the owner of C. D. Otto Notions and Gents Furnishings. The store was located in Wadsworth, Texas. This photograph was taken in 1910.

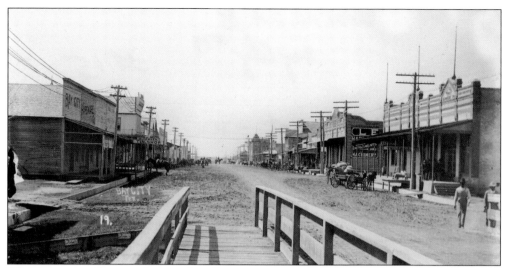

Walkway and Street Scene. A walkway was built over Cottonwood Creek, which runs through the town of Bay City, Texas. Part of this walkway is visible in this scene, looking west on Seventh Street. This photograph was taken in 1908.

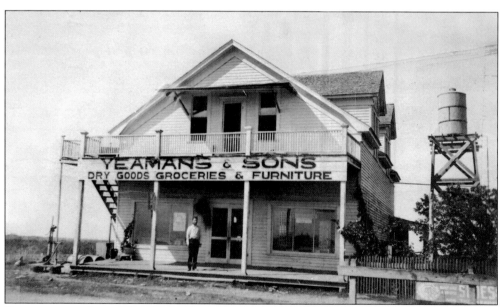

Yeamans and Sons. This dry goods, grocery, and furniture store located in Citrus Grove was owned and operated by A. H. Yeamans and his sons, Lynn and Charles. It was constructed around 1909. Yeamans referred to his customers as "snow diggers." Amos J. Johnson was the manager, and Grace Shuey was a clerk.

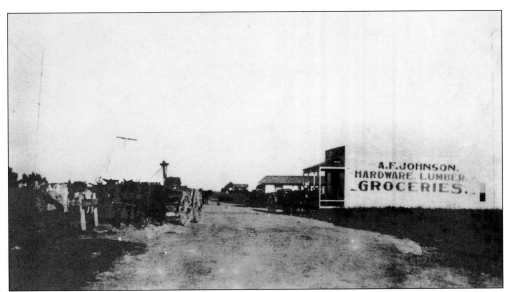

CITRUS GROVE. This street scene of the Citrus Grove community shows dirt streets, horse-drawn buckboards and carriages, and the A. F. Johnson Hardware, Lumber, and Grocery Store.

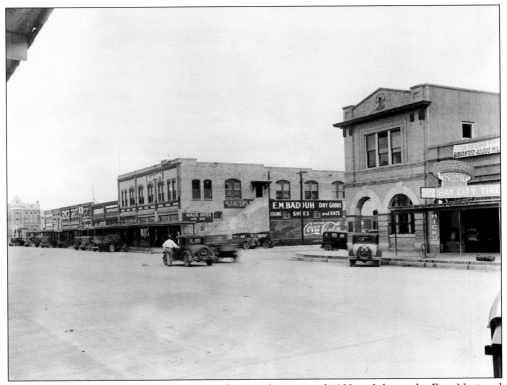

BAY CITY STREET SCENE. This photograph was taken around 1932 and shows the First National Bank on the corner of Avenue G and Seventh Street. On the far left of the photograph at the corner of Avenue F and Seventh Street is the Bay City Bank.

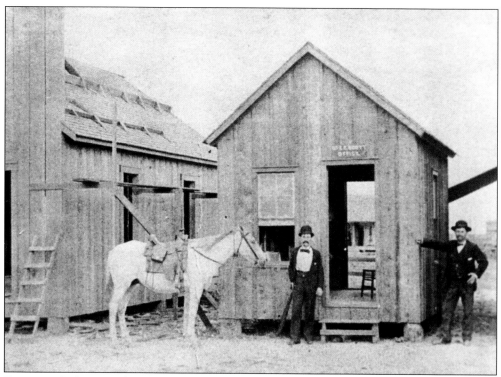

PHYSICIAN'S OFFICE. The clinic of Dr. E. E. Scott was located in Van Vleck, Texas. He practiced medicine in Matagorda County from the late 1800s to 1937.

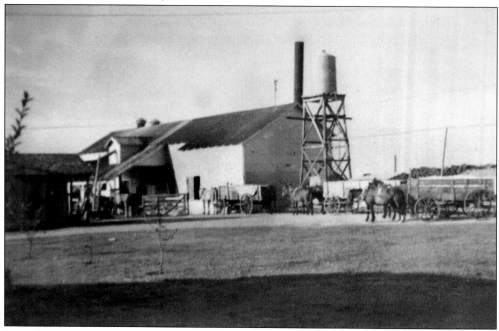

DON TOL GIN. This cotton gin was owned by L. B. and Amanda Bessie Hall, and was located in Pledger, Texas. In 1885, the small community of Pledger had two cotton gins, and by 1892, it had an amazing four gins.

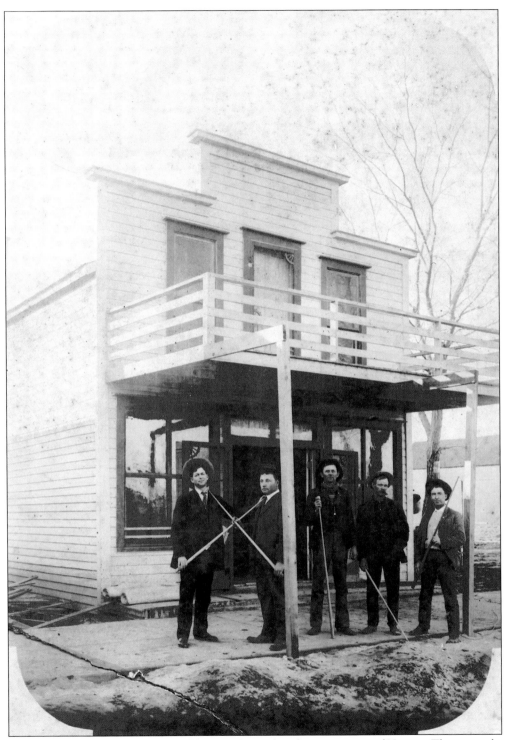

HASIMA STORE. This two-story building was located in the community of Hasima. The cue sticks that the men are holding in this photograph indicate there was probably a pool table located inside the store.

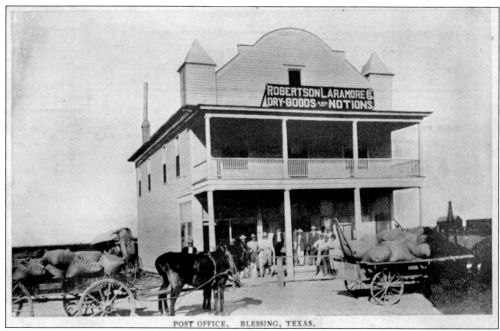

POST OFFICE. BLESSING, TEXAS.

BLESSING POST OFFICE. The Blessing Post Office operated out of the Robertson Laramore Company building. This structure was built about the same time as the Blessing Bank and was situated on the Blessing town square.

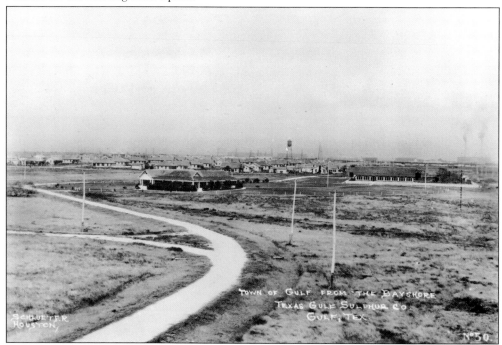

GULF STREET SCENE. This town was built by the Texas Gulf Sulphur Company for its employees. This photograph was taken about 1924. After Texas Gulf abandoned the sulfur mines here for more plentiful mines near Boling, Texas, the town was called Old Gulf. The new town was dubbed New Gulf.

Six

AND A SURREY WITH A FRINGE ON TOP
TRANSPORTATION AND RIVER SCENES

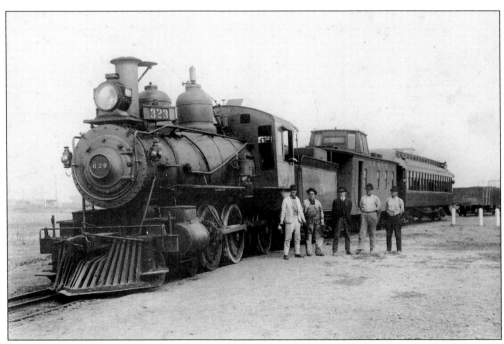

SOUTHERN PACIFIC RAILROAD. The New York, Texas, and Mexican Railway became the Galveston, Harrisburg, and San Antonio Railway (GH&SA) in 1906. In 1934, the GH&SA became the Texas and New Orleans Railway (T&NO), a subsidiary of the Southern Pacific Railroad. Here a group of men stand next to one of Southern Pacific's engines. Second from left is J. H. Hill.

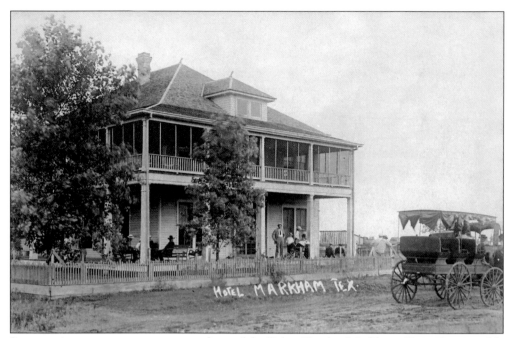

SURREY. A six-passenger surrey sits in front of the Fisher Hotel in Markham, Texas. It is possible the hotel provided transportation to accommodate its guests. Caroline B. Fisher and her brother William Furber purchased the Fisher Hotel in 1905.

FOUR-LEGGED TRANSPORTATION. In 1904, Boltes A. Ryman poses with his mode of transportation, a fine-looking steed. The view is looking east on Mulberry Street in Matagorda, Texas.

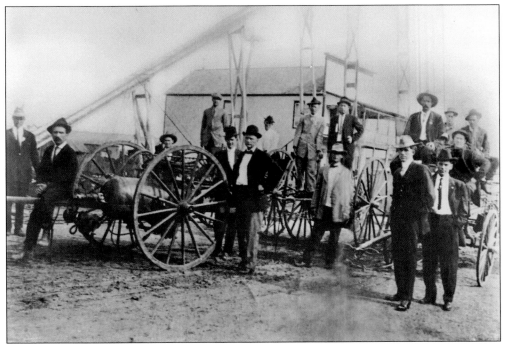

FIRE CARRIAGES. These hand-drawn carriages were used by the Bay City Volunteer Fire Department to battle blazes. This *c.* 1912 photograph shows a pressure vessel carriage (left) and a ladder carriage (right). It is believed that the inclined scaffold in the background was used to drain and dry the hoses.

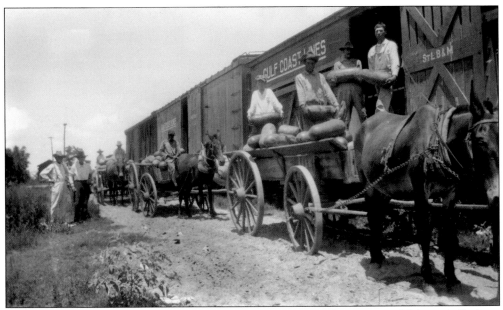

SHIPPING WATERMELON. On this day in 1916, the New York, Texas, and Mexican Railway (later called the Southern Pacific Railroad) is stopped in Ashwood, Texas, while watermelons are loaded for shipping. The watermelons were brought from the farms to the train by mule-drawn buckboards.

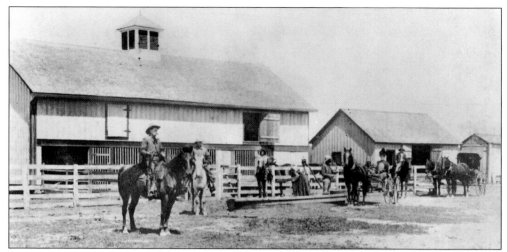

READY TO GO. At Kuykendall Pasture in 1900, ranchers prepared for a day trip. On the far left mounted on the horse is ranch owner Wylie Martin Kuykendall. Seated in the front buggy is Susan E. Pierce Kuykendall, Wylie's wife. The Kuykendalls sold their land in 1902, and the area became known as Buckeye.

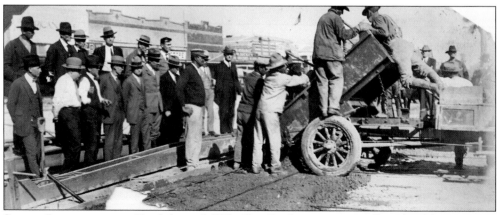

STREET IMPROVEMENTS. Until the mid-1920s, Bay City's streets were still made of dirt, creating a muddy mess when it rained. As the town progressed, the streets were finally improved. Using this dump truck, men poured cement to begin paving the west side of the downtown square.

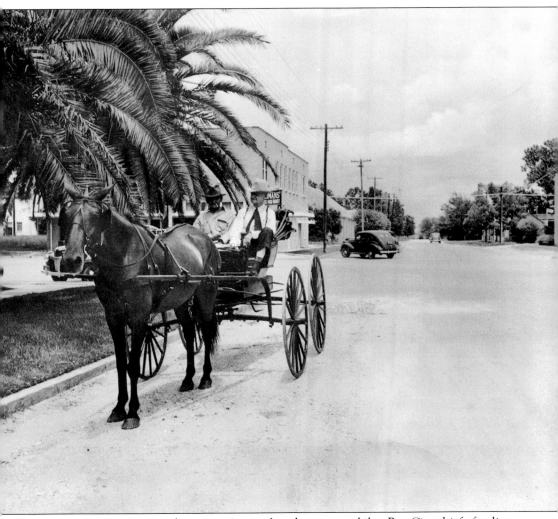

HORSE AND BUGGY. Despite the convenience of modern automobiles, Bay City chief of police Frank Carr (right) and a Mr. Chaddel chose to ride along in a horse-drawn buggy. They are traveling west on Fifth Street, one block from the town square.

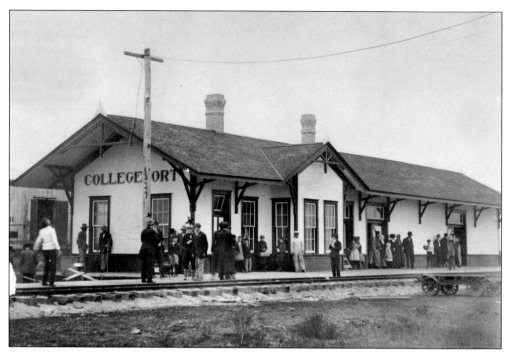

COLLEGEPORT MOPAC DEPOT. The Collegeport Missouri-Pacific (MoPac) Depot was built in 1911 when the railroad was extended to Collegeport. The spur in Collegeport was abandoned in 1933. Materials from the depot were used to build the MoPac House, the community center, and library.

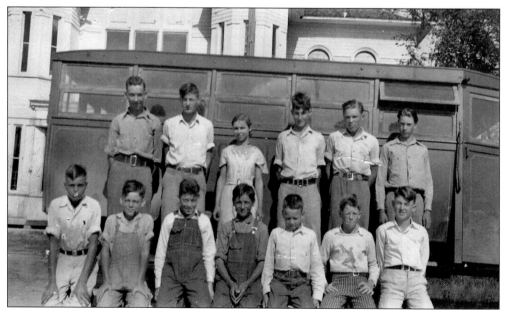

SCHOOL BUS. In 1932, the children in this photograph commuted to and from Jefferson Davis School by school bus.

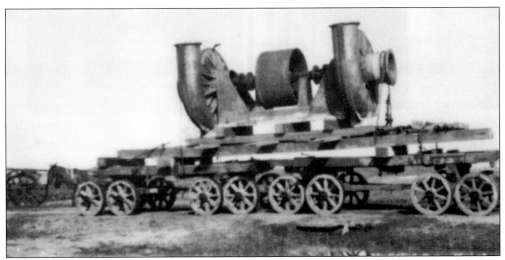

TRANSPORTING MACHINERY. Transporting equipment for the canal systems in 1903 was not an easy task, especially for the mules. This pumping machinery for the 30 miles of the Northern Headquarters Canal System was brought in on wagons pulled by mules.

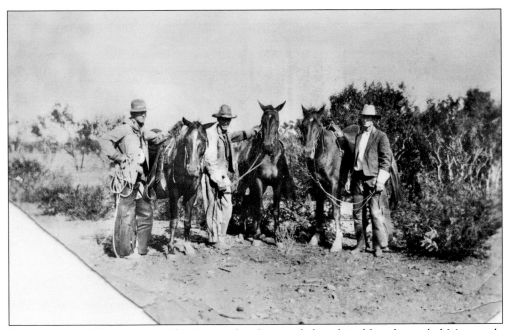

TRAVELING BY HORSEBACK. The Coston brothers and their hired hand traveled Matagorda County by horseback. From left to right are Grover Coston, Wayne Haggor, and Roy Coston.

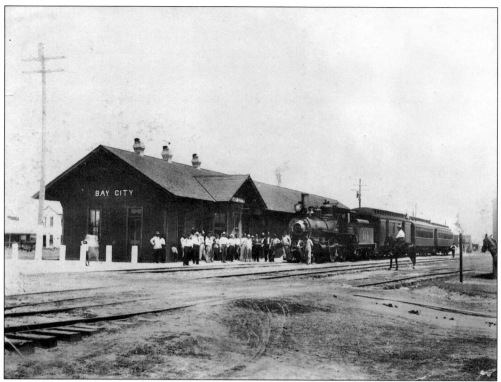

BAY CITY DEPOT. Train excursions were directed toward people who wanted to visit the country's seashores for holiday fun. In the mid-1920s, trains were used to bring troops, weapons, vehicles, horses, and supplies for training sessions at Camp Hulen in Palacios.

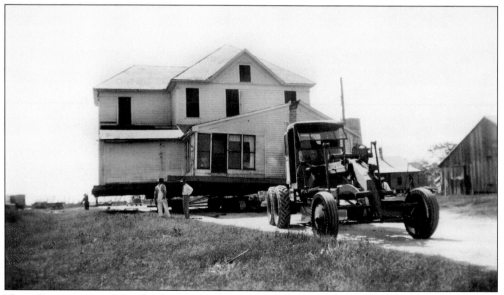

HOME RELOCATION. After the devastating hurricane in August 1942 wreaked havoc on Matagorda, some chose to move their homes inland to Bay City. The George T. Sargent home was relocated in October 1942 to 2101 Marguerite Street in Bay City, Texas.

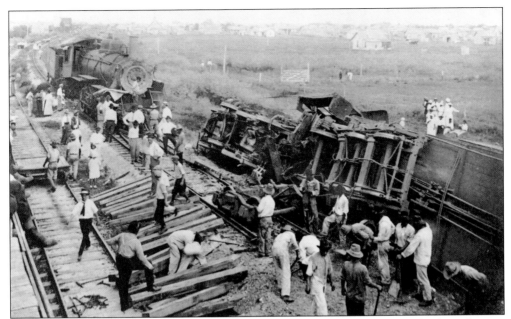

TRAIN WRECK. In 1916, a 50-coach train filled with Minnesota soldiers bound for the valley was pulling out of Bay City when it collided with the D. L. Perry Land Company *Homeseekers Special*. Although the engine and two coaches of the *Special* were overturned, the troop train suffered little damage, and only six people were slightly injured. What could have been a catastrophe turned into a few hours of pleasure for the soldiers as they experienced their first time off. They were welcomed into the homes of residents to share a Sunday afternoon meal before they continued their journey.

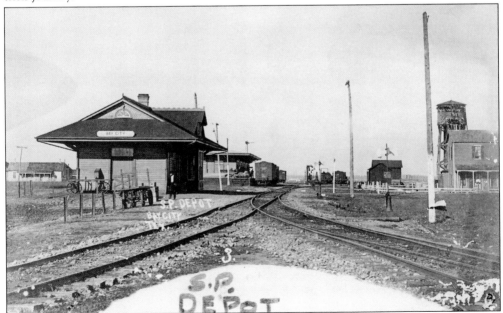

SOUTHERN PACIFIC DEPOT. The Southern Pacific Depot was built around 1901. Besides transporting products from farms to market, immigrants from the Midwestern states traveled the train on excursions trips at reduced rates to be shown Matagorda County acreage for sale.

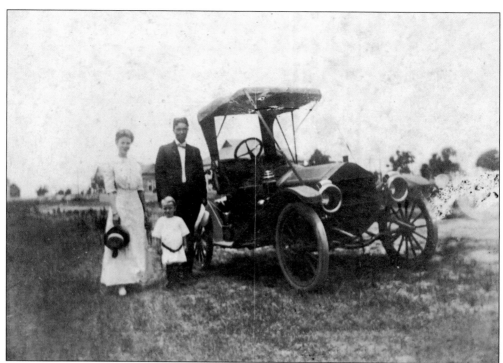

A 1912 FORD. L. O. and Linn Yeamans of Matagorda pose along with their child, Donald, for a photograph in front of their vehicle on May 30, 1912.

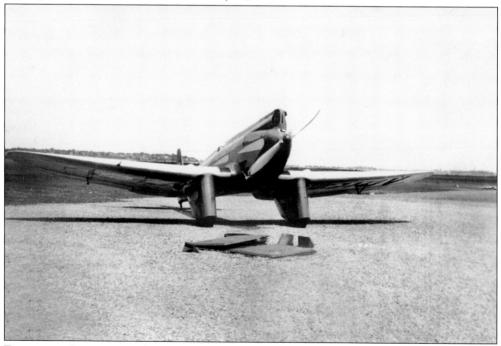

EMERGENCY LANDING. Wiley Post made an emergency landing in Bay City in the early 1930s because of engine problems. Matagorda County resident Johnny Poage helped him make repairs so he could continue his flight.

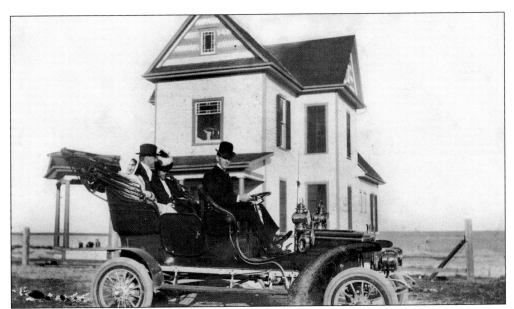

AFTERNOON DRIVE. Friends take an afternoon drive while onlookers peer out the window of Bay City dentist Dr. H. E. Gaedecke's home. The automobile belongs to the driver, J. H. Hill.

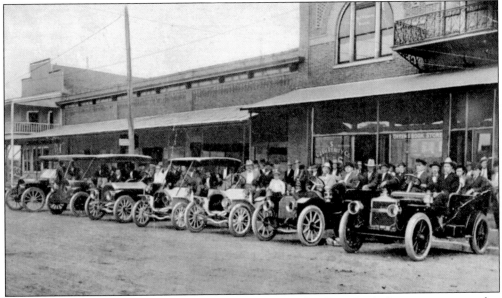

MOTORCADE. This motorcade was formed on the south side of Bay City's downtown square after the completion of the town's water system in 1908. Most of the men in the cars were members of the volunteer fire department. The first automobile on the right is a Maxwell with A. R. Leckie (left) and Speaker Sisk in the front seat and DeWitt Green (left) and Simon Lewis in the back. The next car is a Stoddard Dayton with N. M. Vogelsang (left) and Raymond Cookenboo in the front and Cecil Millican (left) and C. M. Steger in the rear seat. Zenis Schofield (left) and "Dad" Mather occupy the front seat of the first Buick. The next Buick holds Dr. T. C. Brooks (left) and Marshall Boney in the front seat and Dr. John Sloan (left) and Capt. Dick Lewis in the back. Standing next to the last Buick are W. C. Lloyd (left) and Bruce ?. The last two vehicles are Fords with unidentified occupants.

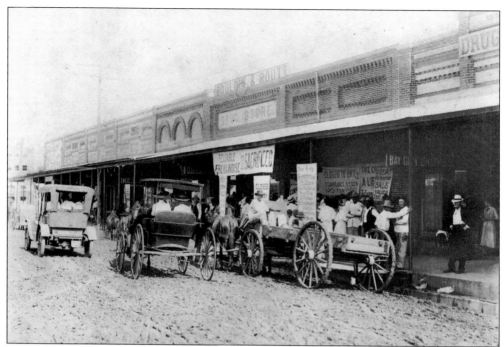

MODES OF TRANSPORTATION. The variety of transportation used in Bay City around 1908 is demonstrated in this photograph. People are traveling on the south side of the town's square in a motorized vehicle, a horse-drawn buggy, and a buckboard.

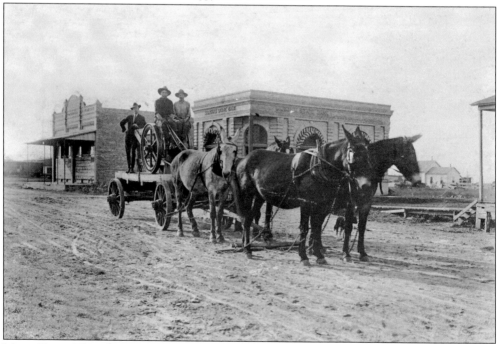

MULE TEAM. This photograph was taken between 1909 and 1910 in front of the State Bank in Markham, Texas. Driving the buckboard drawn by a mule team is John T. Gore. Standing in the back dressed in his fine suit is Will Swindler. The other passenger is unidentified.

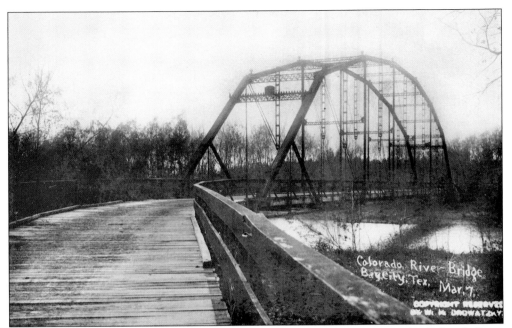

COLORADO RIVER BRIDGE. This wooden bridge was the passageway across the Colorado River entering the west side of Bay City, Texas. The wooden structure with an iron span was built around 1902. The bridge was demolished in 1928 so a new modern one could be constructed.

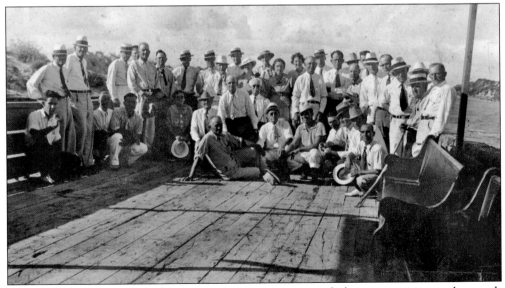

RIVER EXCURSION. A group of businessmen and women enjoyed a boating excursion to the mouth of the Colorado River. The trip was in celebration of a completed river project in 1902.

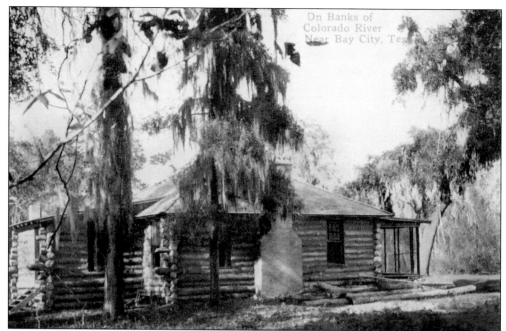

RIVER CABIN. This log cabin was situated close to the banks of the Colorado River near Bay City. The photograph was taken in 1911.

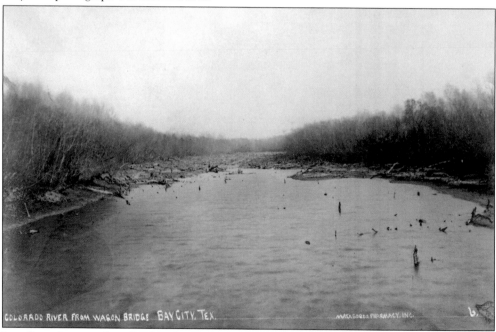

LOG JAM. A river raft, or log lam, had been collecting for nearly 100 years in the Colorado River before it was removed. Rice farmers did not want the raft removed because it caused water to spread out, creating storage reservoirs. In the dry season, rice was irrigated with gravity canals from these reservoirs. Despite their objections, a deep, long channel was cut east of the raft in the mid-1920s. Key logs were removed, and explosives were used to remove part of the east edge of the raft. The force of the flowing river assisted in removing the rest of the raft.

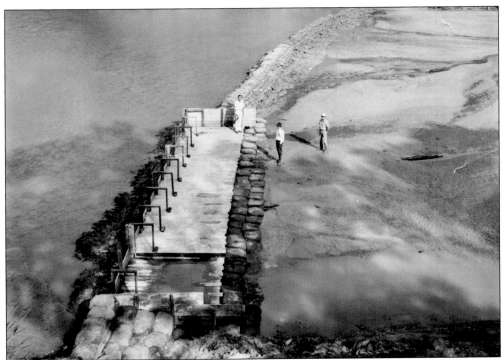

RIVER DAM. These three gentlemen are inspecting the newly constructed dam on the Colorado River. Standing in the center is Cooper Gusman. This dam was built across the section of the river that flows through Bay City to help control flooding in the area. The dam was completed in 1965.

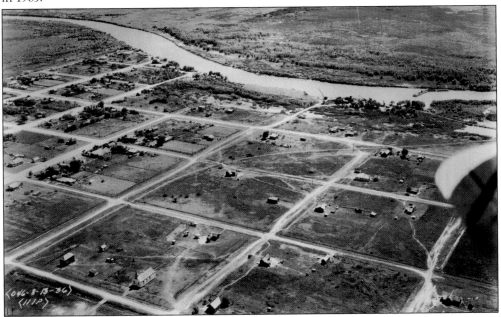

DREDGING THE COLORADO. This aerial photograph was taken in 1936 when a new channel was being dredged in the Colorado River. The Matagorda town site is located in this section of the river. Situated next to the riverbank is a shell dock.

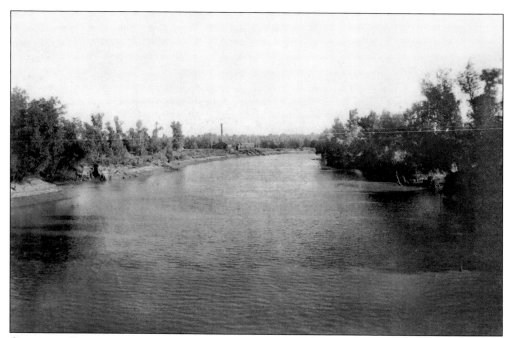

COLORADO RIVER. Many people are confused by the name of the river that runs through Matagorda County. Bearing the same name as another river that begins in Colorado and empties into the Gulf of California, this river is quite different. The headwaters are in northwest Texas, and it empties into Matagorda Bay and the Gulf of Mexico. This photograph shows the river near Bay City; a pumping plant can be seen on the left.

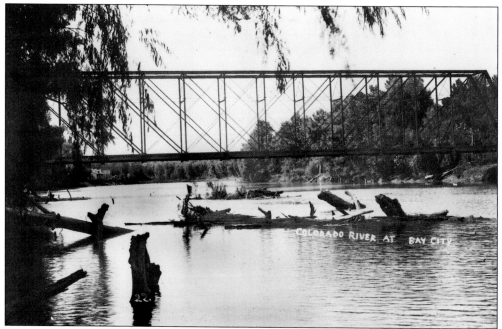

BRIDGE OVER THE RIVER. A new bridge was erected after an older one was torn down in 1928. The new bridge was constructed at the end of the Old River Road near the location where Elliott's Ferry once operated.

Seven

O COME ALL YE FAITHFUL

RELIGION AND CHURCHES

FIRST PRESBYTERIAN CHURCH. In 1898, residents decided to organize a Presbyterian church in Bay City. Services were conducted in the courthouse for more than four years until a white wooden sanctuary was completed in 1903. This building served the church members until a new one was erected in 1936; Robbins Memorial Hall was completed in 1938. This church was dedicated in 1994 as a Matagorda County Landmark.

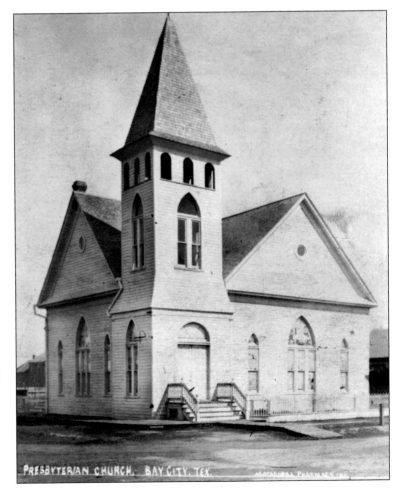

PRESBYTERIAN CHURCH, BAY CITY, TEX.

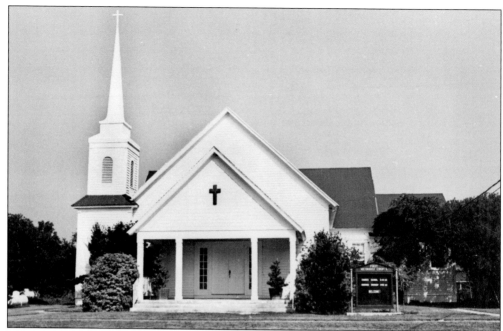

MATAGORDA UNITED METHODIST CHURCH. The Reverend Jesse Hord founded this church organization in Matagorda in 1839. In 1854, a hurricane destroyed the three-year-old church building. In 1869, services were being held in the courthouse and later in the schoolhouse. The church in this photograph, completed in 1893, was constructed of longleaf yellow pine and cypress shipped in from Galveston. This building, still in use today, received a state historical marker in 1968.

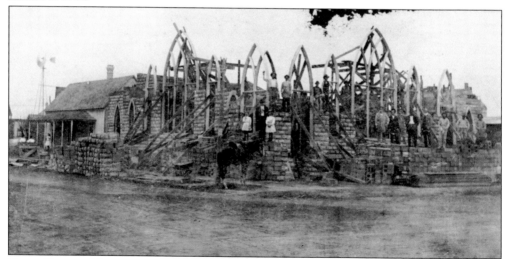

FIRST UNITED METHODIST CHURCH. Construction workers took a moment away from their job of erecting the First United Methodist Church in Bay City to pose for this photograph. The gentleman and girls standing behind the horse are possibly the minister, G. W. Schroeder, and his daughters. The church, completed in 1909, was constructed of stone blocks, and stained-glass windows were used. The LeTulle Education Building was added in 1937. This sanctuary was replaced and the LeTulle Education Building renovated in 1957. It received a state historical marker in 1986.

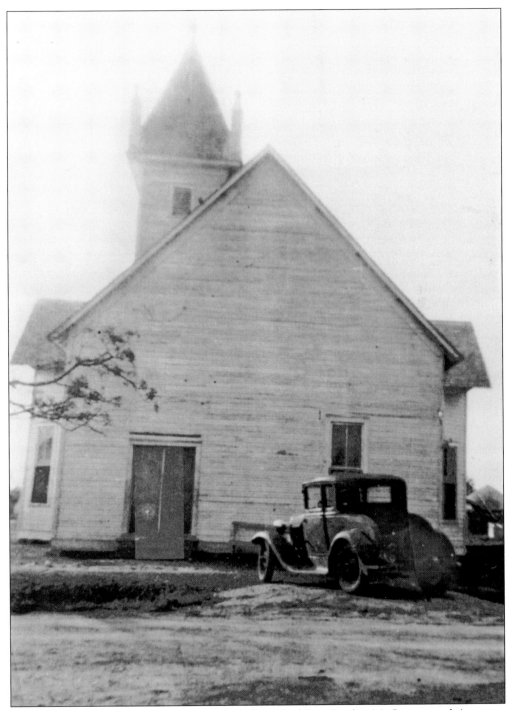

TYREE CHAPEL CHURCH. Jane Lewis, with the aid of Rev. Booker McQuirter and Augustus Hardeman Sr., began raising money in 1894 to build the first African Methodist Episcopal church in Bay City. John Sutherland, owner of the local lumberyard, donated some of the lumber. Nearly seven years later, Tyree Chapel was completed in 1901. The building suffered damage beyond repair in a 1909 storm but was rebuilt the following year.

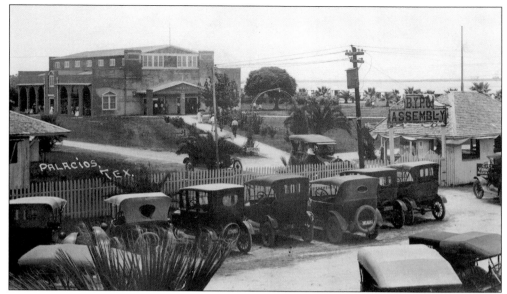

BAPTIST YOUNG PEOPLES UNION. Near the start of the 20th century, the Baptist encampment site was moved from LaPorte to Palacios, Texas. The auditorium was rebuilt, and camp for the Baptist Young Peoples Union was held July 3–12, 1906. Tents, cabins, and rough rooms were available in the early years. Most received their meals from food cooked on open fires, but first-class meals could be purchased at a restaurant on the campgrounds. This photograph shows the memorial building donated in 1923 by C. W. Caldwell, which replaced the LaPorte Tabernacle. It was given in memory of a visitor who was pulled under by an undertow and the seven people who all drowned trying to rescue her. The memorial building was destroyed by a hurricane in 1942 and was replaced in 1944. Over the years, the encampment has gone through many structural additions and is now known as the Texas Baptist Encampment. A Texas historical marker was placed at the main entrance in 1969.

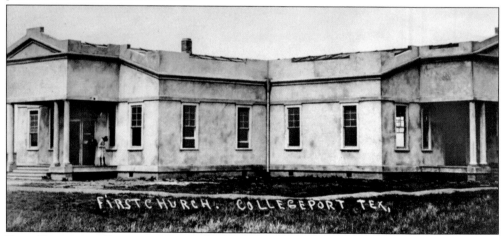

FIRST FEDERATED CHURCH. Organized on November 30, 1909, the first recorded church service held in this Spanish-style stucco church was on November 27, 1910, in Collegeport. After nine years, M. A. Travis resigned as pastor, and for two years, only occasional services were held. Federated members decided in 1922 to transfer to the Presbyterian church. A new church was completed in 1956. It received a state historical marker in 1996. It is now called the Texas Baptist Encampment—the name at the time of the photograph was the Baptist Young Peoples Union.

CHRIST EPISCOPAL CHURCH. Organized on January 27, 1839, the Christ Episcopal Church is the oldest Episcopal church in Texas. A pre-cut church building was purchased and shipped from New York, and was erected in time for Easter service in 1841. It was destroyed by a hurricane in 1854 and was rebuilt on the same site. Several items were salvaged and used in the new church, including the altar, communion rail, altar cross, and pews. The church received a Texas Centennial Marker in 1936 and was dedicated as a Recorded Texas Historical Landmark in 1962.

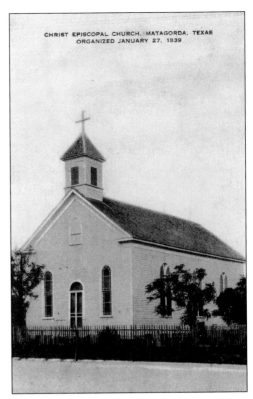

HOLY CROSS CATHOLIC CHURCH. The Catholic church was built and dedicated in 1909 at the corner of Avenue M and Fifth Street in Bay City. Construction of a rectory was completed in 1920, and a school was built in 1940. As membership increased, plans for a new church, school, rectory, and a sisters' home were granted from the bishop at the Houston-Galveston Diocese. The new facilities on Katy Street were completed and dedicated in 1949. Later a library and cafeteria were added to the school. It received a state historical marker in 2007.

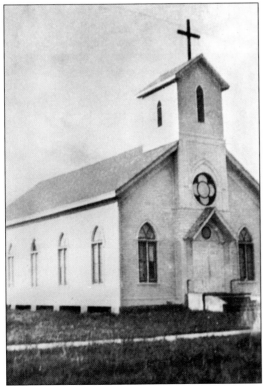

MOUNT PILGRIM MISSIONARY BAPTIST CHURCH. Slaves from various plantations along lower Caney Creek would gather on Sundays to worship. In 1885, after the Civil War ended, they acquired the land necessary to build a church. Church members and Rev. Anthony Morton (or Martin) erected a building that served as a church and school until around 1930. It became a Matagorda County Historical Marker site in 2004.

BAPTISM. In this photograph taken around 1890, new members of the Tres Palacios Baptist Church prepare for baptism in the Tres Palacios Creek. It was customary for Baptists to be immersed in river or creek water for baptismal ceremonies in this era.

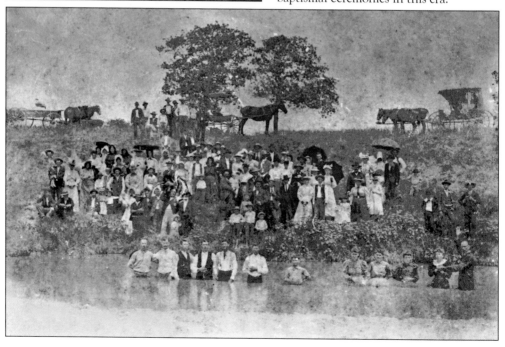

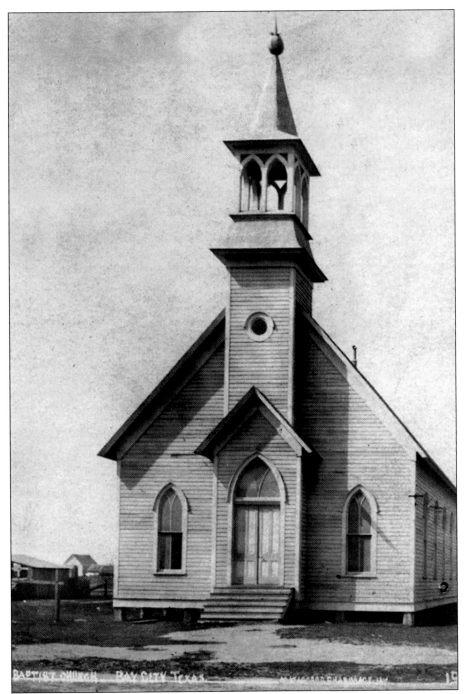

First Baptist Church. After worshipping in a commercial building and the Methodist Church South for more than seven years, Baptist members in Bay City erected their first sanctuary in 1903. The 1909 hurricane destroyed this building, which was replaced in 1915 with a tabernacle and later a brick building. An auditorium was erected in 1941, and an educational building was constructed in 1947. In 1994, this building received a Matagorda County Historical Marker. The brick building that replaced this one also received a historical marker.

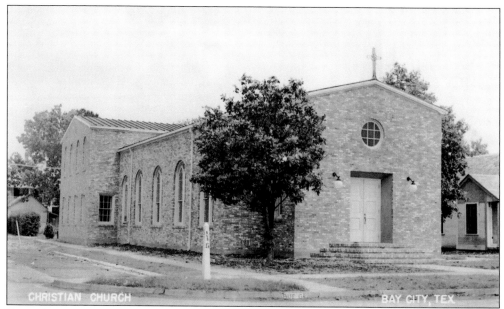

FIRST CHRISTIAN CHURCH. The first sanctuary building was destroyed by a 1909 storm, rebuilt, damaged again in 1915, and rebuilt once more in Bay City, Texas. The church began to grow after 1916, and later another building was constructed behind the original one to include Sunday school rooms, social rooms, and a kitchen. Looking forward to future growth, members erected a new church across town in 1960. The building became the chapel for First United Methodist Church.

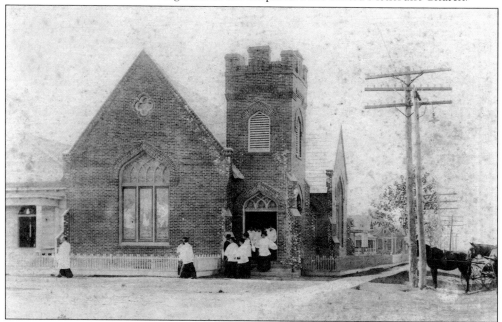

ST. MARK'S EPISCOPAL CHURCH. Church choir members exit St. Mark's Episcopal Church in Bay City after a worship service. This structure was constructed in 1911 following the destruction of the original 1901 building during the hurricane of 1909. The redbrick building with stained-glass windows has twin towers along with a manicured courtyard. A Texas sesquicentennial marker was unveiled for this church in 1986.

Eight

COEXISTENCE
INDUSTRY IN THE COUNTY

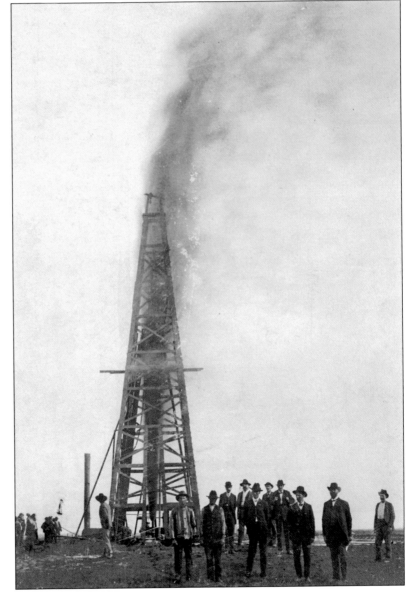

"BIG HILL." After several failed attempts, Dr. P. S. Griffith drilled an oil well from a 97-foot-tall derrick on the William Simpson League near Gulf, Texas. The well blew out at 850 feet in May 1904. It produced an average of 4,000 barrels per day, but by December, production declined, and all but one man left. A short while later, a storm blew down all the derricks, and the site was abandoned.

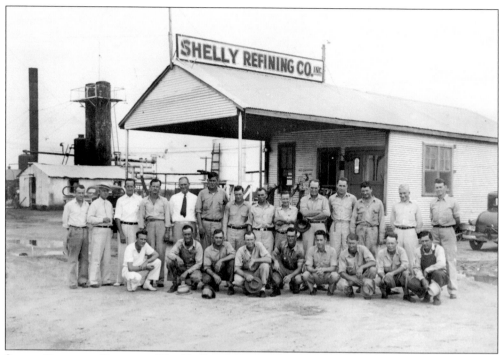

SHELLY REFINING COMPANY. The Shelly refinery was located in Chalmers near Bay City. In 1940, the company was the chief business there; by 1952, the refinery was no longer in operation.

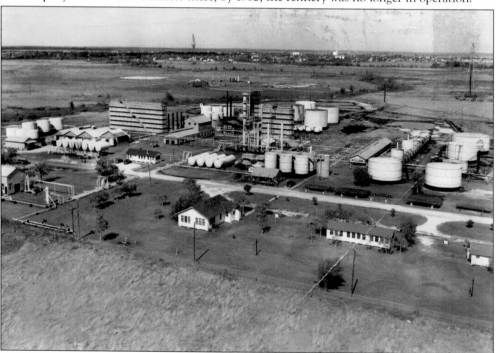

HAMMAN OIL AND REFINING COMPANY. This aerial view in 1940 shows the production area, gas unit, boiler house compression station, and the Cleveland Well No. 2 at the Hamman Oil and Refining Company. This company was located off Hamman Road in Bay City, Texas.

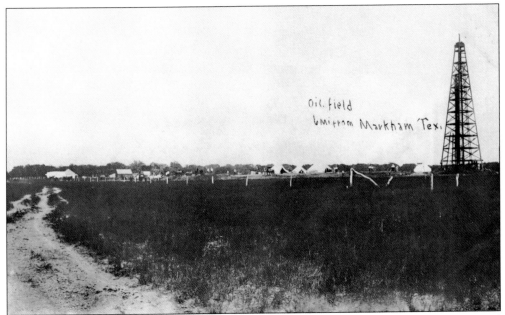

OIL FIELD. This oil field was located six miles from Markham, Texas, around 1910. Tents and buildings shown in the background were erected to accommodate related work and employees here because of the activity in the oil field.

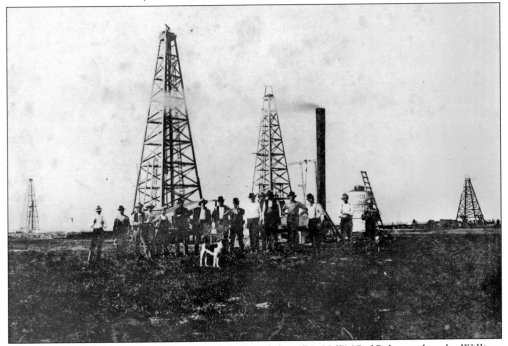

"BIG HILL" OIL DERRICKS. William Cash believed that "Big Hill" (Gulf), located in the William Simpson League, contained another oil field, and with W. T. Goode, he began plans for production in 1901. The first well drilled in January 1902 produced gas. Two more were drilled without success. The Lane-Sutherland Syndicate then drilled a well north of Cash's. Dr. P.S. Griffith later bought the Lane-Sutherland Syndicate. The dig was not successful.

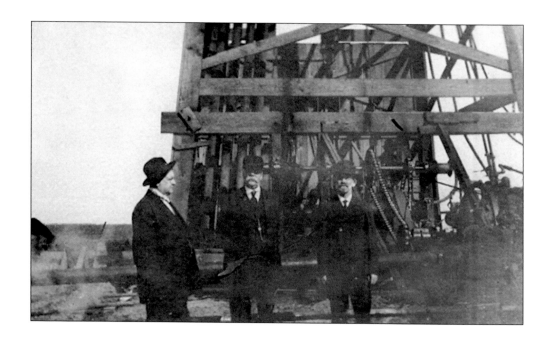

OIL IN CLEMVILLE. These oilmen are checking out the oil wells on Henry Parker League in Clemville, Texas. Clemville was named for F. J. Clemenger, who helped develop the oil field in the area. F. J. Clemenger and R. H. Danner organized companies to drill on leases obtained from the Hardy Oil Company. After one well, Danner sold his share to G. R. Burke—just before the Clem Well blew a huge gusher.

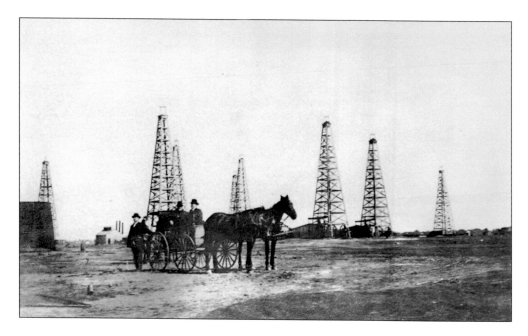

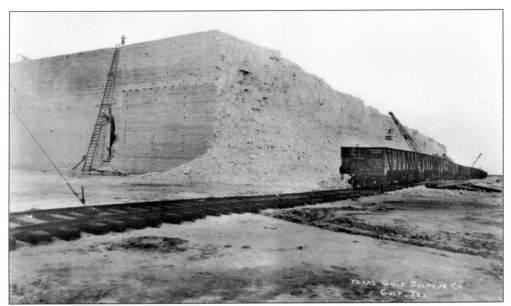

TEXAS GULF SULFUR MOUND. Loading sulfur into railcars from the sulfur mound at Gulf, Texas, was one of the multitude of tasks performed at the Texas Gulf Sulphur Company. Mining operations began on March 9, 1919, and this was one of the chief industries for the county until it was depleted in 1936. There were three important sulfur mines supplying the United States during these years. One was located in Freeport, Texas, another in Sulphur, Louisiana, and the largest in Gulf, Texas. Sulfur was discovered while drilling for oil near the shore of Matagorda Bay from 1901 until 1905, which led to the mining of sulfur in Matagorda County.

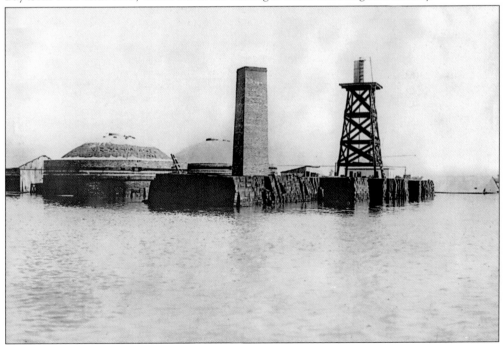

BRICK FACTORY. Bay City was the home of this brick factory operation around 1902. The factory was abandoned, and few records exist about its history.

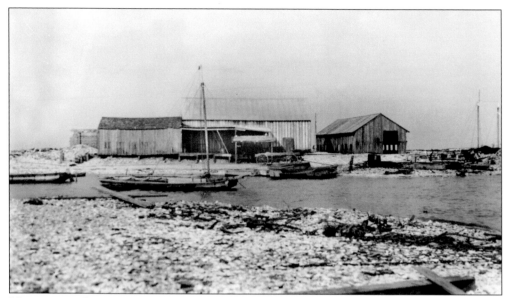

MATAGORDA OYSTER HOUSE. In 1901, the town of Matagorda, Texas, had a fleet of oyster boats and an oyster packing facility. The *Texas State Gazette* reported in 1914, "Because of the town's location, it is one of the most important fish and oyster points on the coast."

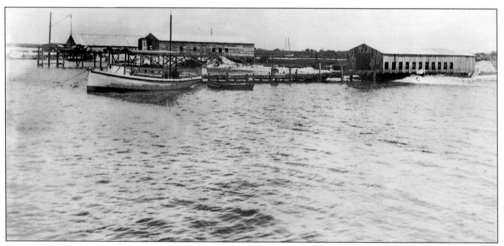

PALACIOS FISH AND OYSTER HOUSES. Soon after the Palacios town site was laid out, fish and oyster businesses were built on the waterfront. Joe Deutsch opened and operated the Liberty Fish and Oyster Company in 1903 (right), and the Ruthven and A. R. Hillyer Packing Company (center) opened later that year. J. J. Burkes opened a third packinghouse shortly thereafter.

Nine

DISASTERS
HURRICANES, FLOODS, AND FIRES
THROUGH THE YEARS

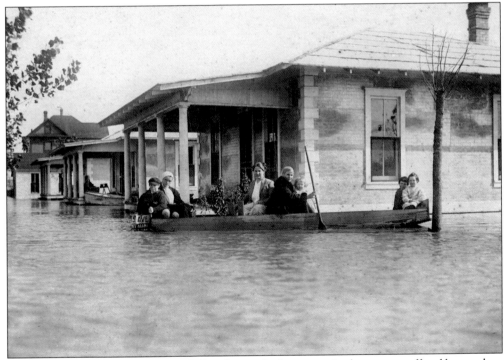

FLOOD RIDES. On December 6, 1913, Bay City and other towns in the county suffered horrendous rains. The Austin Dam gave way during the heaviest part of the rainstorm, causing even more flooding. Even in the face of the daunting property and livestock loss throughout the area, those who had boats would tour neighborhoods, inviting friends to join them for a boat ride.

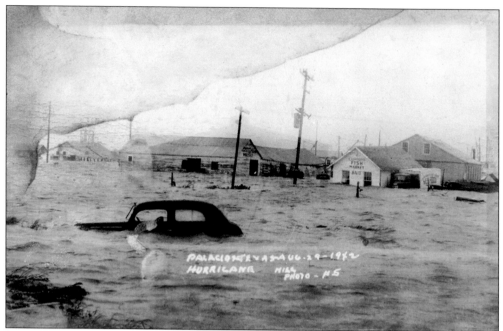

PALACIOS FLOOD. The town of Palacios, Texas, suffered heavy damage from high winds and floodwater during the unnamed hurricane that came ashore on August 29, 1942.

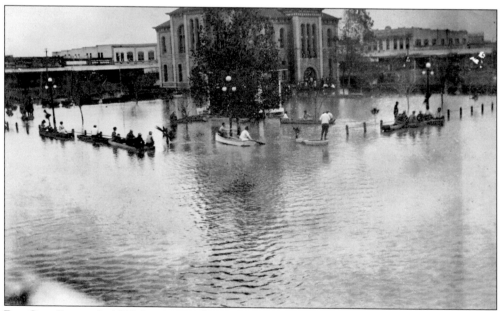

BAY CITY FLOOD. In 1908, heavy rains from a storm flooded the streets of Bay City. The spectacle of boats and horses around the courthouse demonstrates that the high waters did not deter people from coming outside.

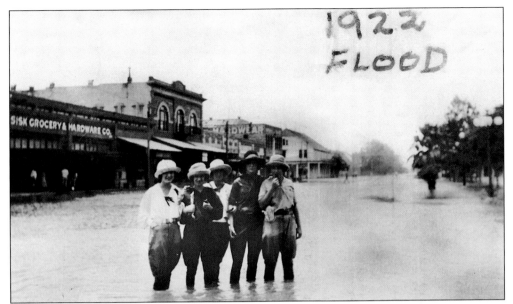

THE 1922 FLOOD. These ladies frolic in the 1922 floodwaters on the south side of Bay City's downtown square to cool off from the scorching heat. Wearing hats to protect against the sun, they are, from left to right, a Mrs. Whaley, Clara Mae Cash, a Miss Creech, Beatrice Poole, and Anna Gartrell.

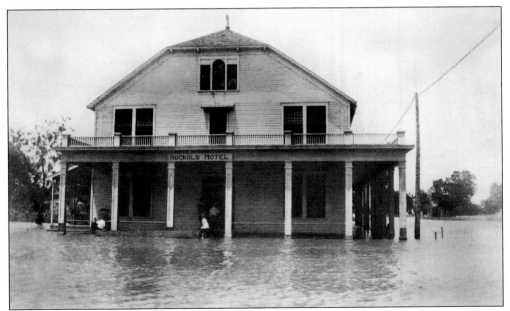

FLOOD DAMAGE, 1913. The 1913 flood resulted in the loss of lives, livestock, and property. The costs of property damage were estimated to be in the millions of dollars. The Nuckols Hotel, situated on the southwest corner of Avenue F and Sixth Street, fared well compared to many other buildings. For instance, the Hotel Wylie's entire first floor was flooded by waters from Cottonwood Creek and was destroyed. The local power and ice plant was completely underwater. Although the Nuckols Hotel managed to escape complete ruin from the flood, it was destroyed by a fire in 1945.

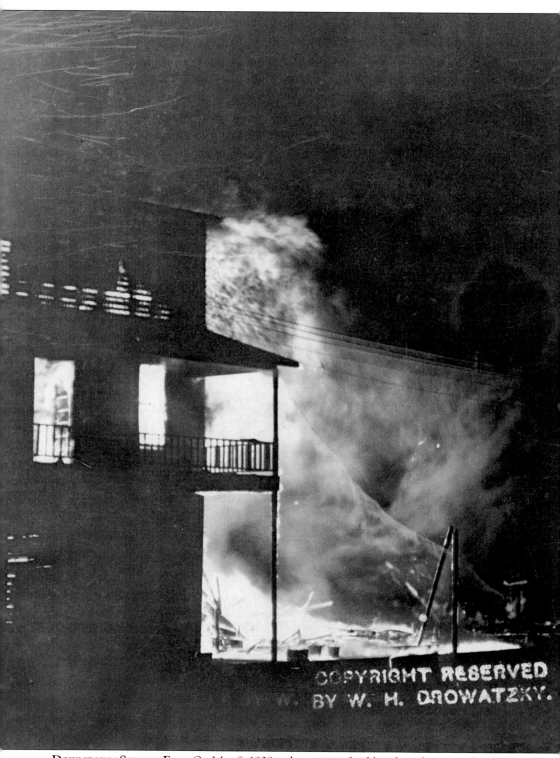

Downtown Square Fire. On May 8, 1908, a devastating fire blazed on the west side of Bay City's downtown square. The inferno nearly destroyed the entire block, sparing only the D. P. Moore

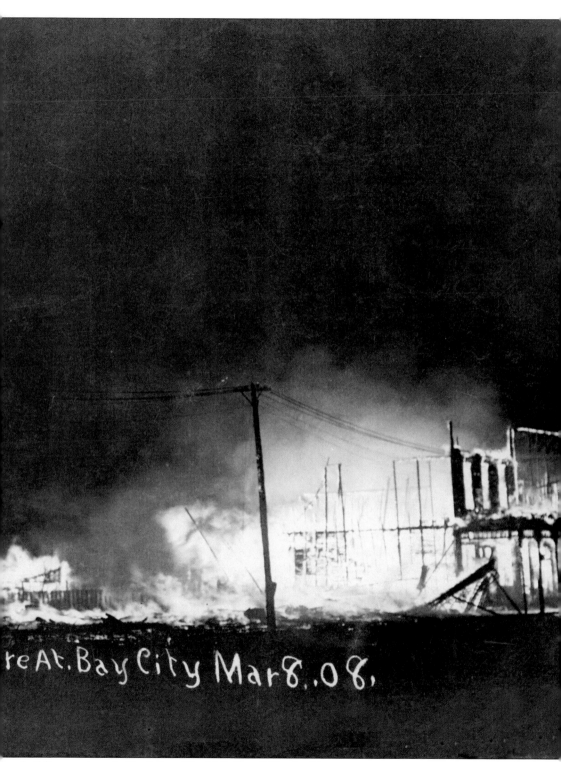

re At. Bay City Mar 8..08.

building, an ironclad building. The U.S. Post Office building was one structure that succumbed to the fire; a new post office was completed in 1918 to replace the one that burned.

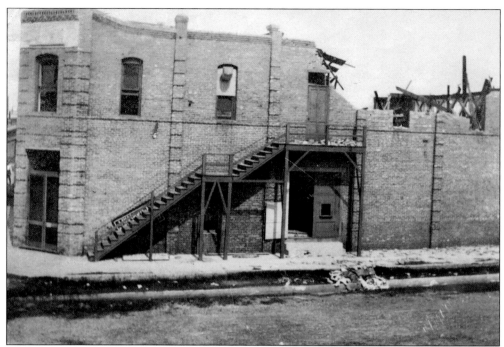

HURRICANE AFTERMATH, 1909. Bay City's first opera house was partially damaged by a destructive hurricane. It did not prevent the county from continuing to enjoy the new form of entertainment. The building was repaired in the same year, and road shows continued to perform there.

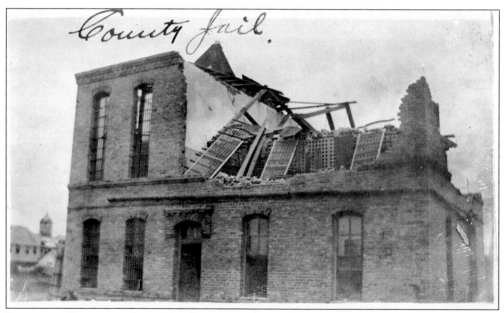

County Jail.

JAILHOUSE DAMAGE, 1909. The damage to the jailhouse from the 1909 hurricane was so enormous it had to be torn down. Fortunately for the prisoners, they had been relocated two days prior to the storm, most being moved to the state farm. A new jailhouse was soon erected to replace the one lost.

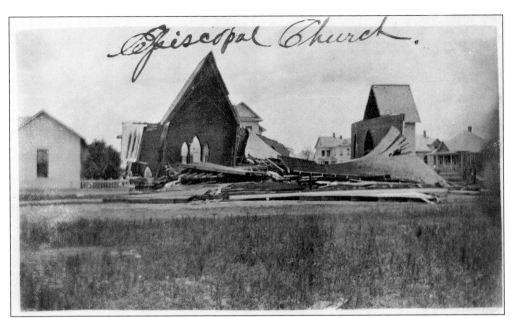

DAMAGE TO ST. MARK'S. All of Bay City's church buildings were badly damaged or destroyed by the fierce hurricane of 1909. The eight-year-old St. Mark's Episcopal Church building was ruined, along with all its mission records. The congregation began to rebuild the church less than a year later. Material salvaged from the damaged building was used to erect a parish house, which served as a temporary place of worship.

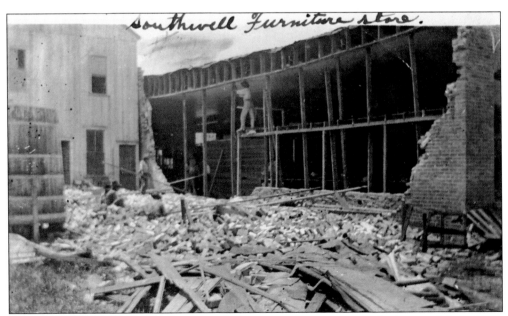

SOUTHWELL FURNITURE AND JEWELRY. A devastating hurricane roared ashore on July 31, 1909, wreaking havoc throughout the county. This structure housing the Southwell Furniture and Jewelry Shop in Bay City suffered heavily. All the furniture inside the building was ruined as well.

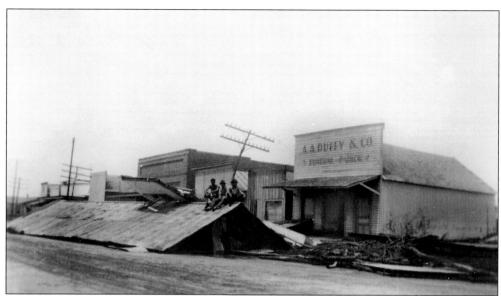

THE 1942 HURRICANE STRIKES. An unnamed hurricane in 1942 left a swath of destruction in its path. The A. A. Duffy Funeral Parlor, a cleaning and pressing shop, a barbershop, and Berg's Store are in the background of the rubble left in the street after the storm passed through.

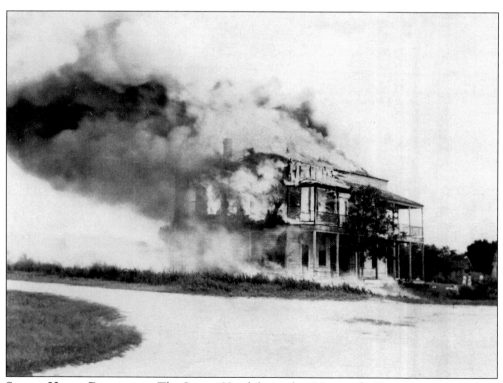

SAVAGE HOTEL DESTROYED. The Savage Hotel, located in Matagorda, Texas, was once a place of luxurious comfort for overnight guests. A fire broke out on August 29, 1937, destroying the hotel.

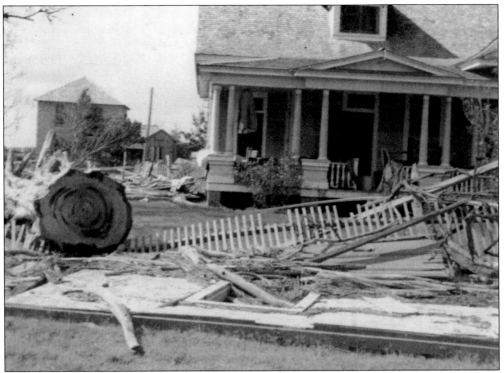

A 1945 STORM. Many houses were destroyed or left uninhabitable after a storm hit the town of Matagorda in 1945. Few were left undamaged—roofs, porches, and fences were destroyed on many homes.

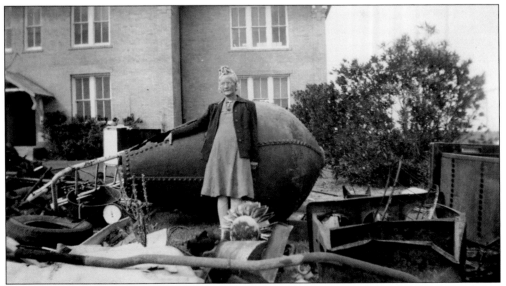

SCHOOL GROUNDS. Although the school in Matagorda, Texas, survived the 1942 hurricane, debris littered its grounds. Myrtle Watson stands in the schoolyard, surveying the chaos left behind from the high winds. The brick school building withstood the high winds quite well, and even the windows were spared.

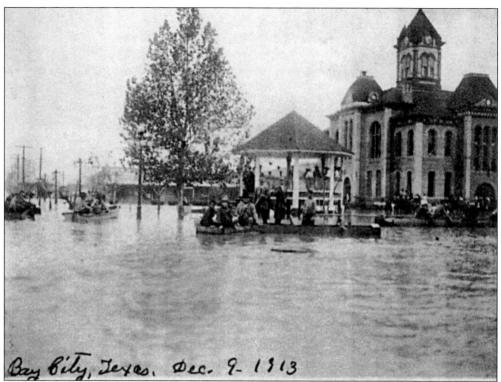

Bay City, Texas. Dec. 9- 1913

FLOOD ENTERTAINMENT. When the Austin Dam gave way during the heaviest part of a devastating 1913 rainstorm, the town of Bay City was inundated. In order to keep the townspeople's spirits up, different area bands played at the bandstand, located on the courthouse lawn. Citizens would parade around the square in rowboats and motorboats before gathering around the bandstand to enjoy the concert.

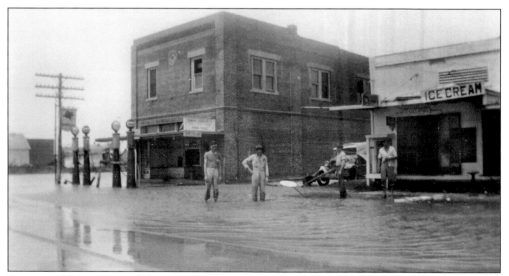

FLOODED MATAGORDA. The unnamed hurricane in 1942 caused floodwater to rise in many commercial buildings and homes in Matagorda, Texas. The damage was exacerbated because the water rose so quickly but went down very slowly.

Ten

ENDING ON A HAPPY NOTE
ENTERTAINMENT AND OTHER FUN THINGS

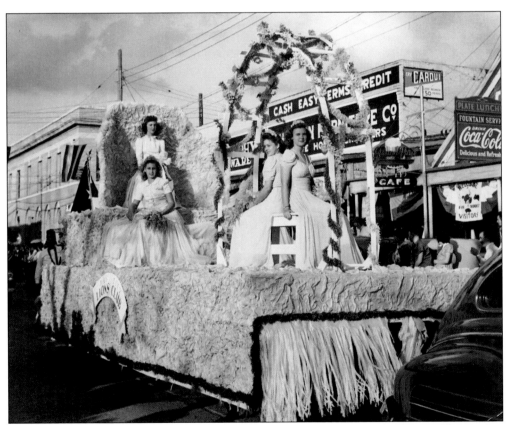

FIRST RICE FESTIVAL PARADE. The Bay City Lions Club sponsored its first Rice Festival in 1941 in downtown Bay City, Texas. A parade featuring Rice Festival Queen Aubin Cox was part of the festivities. Other contestants shown above are, from left to right, Yvonne Holbrook, Lily Richers, and Ann Cobb Vaughn. The Rice Festival is an annual event that continues today. It is run completely by volunteers from the local Lions Club.

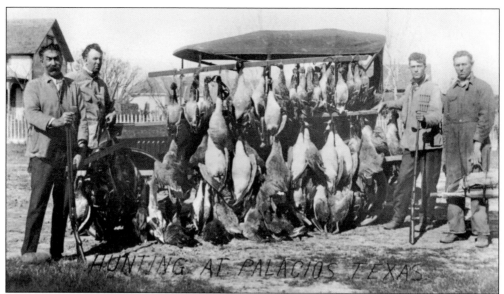

BIRD HUNTING. Matagorda County has always offered a plethora of venues for bird hunters. These men, hunting near Palacios, show off the result of their successful hunt. It is possible they hunted at Wells Point, which was known as one of the better places to hunt geese and duck. Hotel Palacios used to advertise "wild ducks, geese, quail, and wild turkey are only a short distance away."

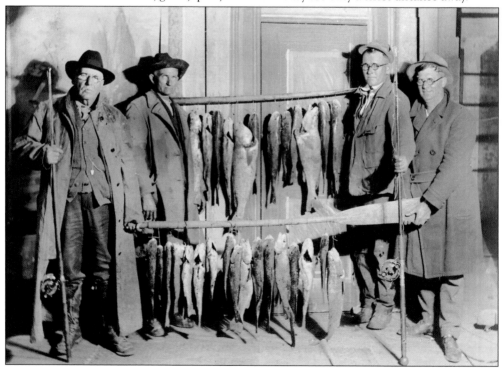

CATCH OF THE DAY. The bays and rivers of Matagorda County have always provided locals with recreational opportunities, including both fresh and saltwater fishing. These men show off their good luck with 29 fish strung across oars in 1935. The men are identified from left to right as John Sutherland, Bob Harrison, unidentified, and Rev. Otis Rainer.

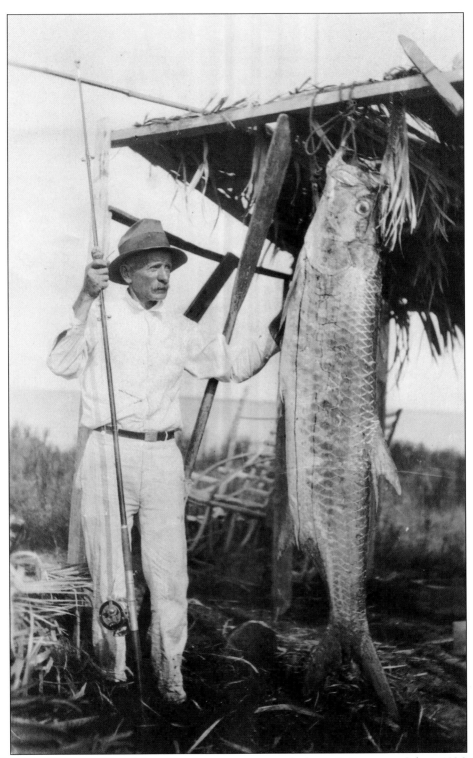

WHOPPER TARPON. This 6-foot, 2-inch tarpon was caught by B. F. Bryant on July 4, 1926, off the coast of Palacios, Texas.

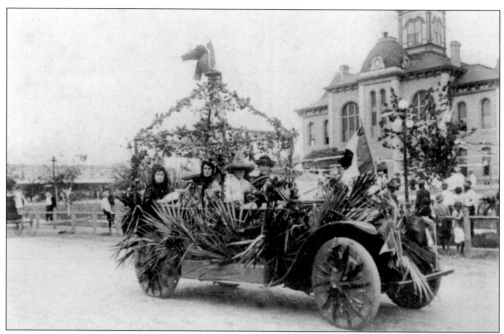

THE 1912 PARADE FANFARE. Bay City has been the scene for many parades over the years. This float was one in the Commercial Parade during the American Legion Fair and Carnival, which lasted three days in November.

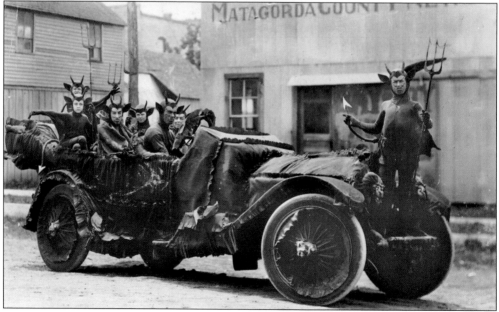

THE DEVIL YOU SAY. During a 1912 parade in Bay City, this unusual float drew the attention of many citizens and even frightened a few of the youngsters. Helen Kilbride's car, "the Yellow Peril," was decorated in red crepe paper. Holding the pitchfork at the rear of the car is Betty Kilbride; the driver is Jamie Peeddy. Standing on the front with the pitchfork is Jimmy Britten. Passengers are (from left to right) Margaret Kilbride, Annie Jay Hamilton Sholars, Elizabeth Klein, and Helen Kilbride.

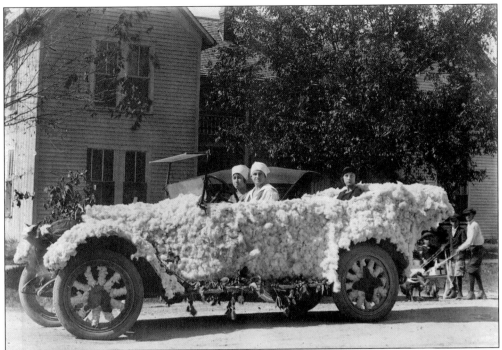

ARMISTICE PARADE. Matagorda County celebrated the World War I armistice with the waving of flags and banners, the closing of businesses at noon, and, of course, a parade. The parade was held on November 11, 1918, and wound its way around the downtown square in Bay City. The Red Cross float, decorated with cotton, is passing by the Van Shi Inn. Driving is Mary McLendon Underwood, the front passenger is Mary Earle Underwood, and seated in the back is Eddie McLendon Henderson.

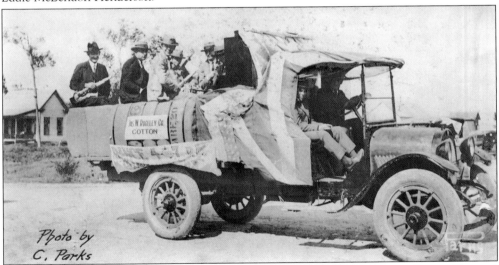

COTTON IS KING. Rolling in the Commercial Parade during the American Legion Fair and Carnival is James W. Rugeley's cotton float. The banner on the side advertises a dance to be held from 4:00 to 7:00 p.m. Among those seated in the back are, from left to right, (first row) musicians James Castleton, Weldon Smith, and Grover Coston. Professional photographer C. Parks photographed this agricultural float.

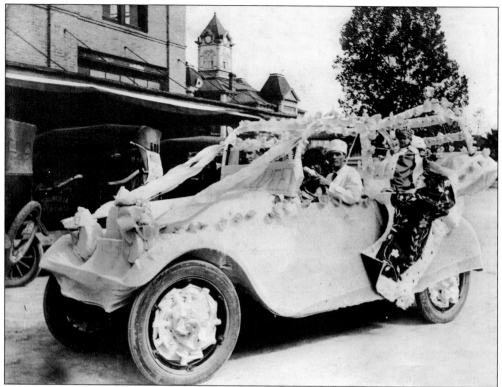

QUEEN MARY. This decorated car, driven by J. W. Ingram, carries parade queen Mary Ann Morton in a 1923 parade. Other passengers are D. B. Hinton and Genevieve Morton. The Matagorda County Courthouse can be seen in the background.

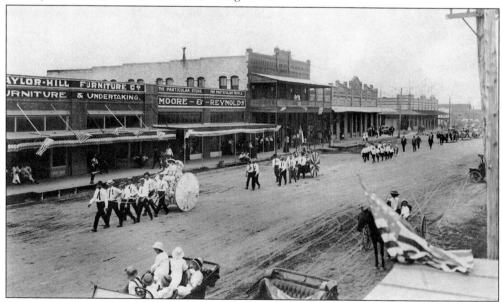

HAND-POWERED FLOATS. This parade around 1915 was traveling west on Seventh Street in downtown Bay City. Notice how the first two floats are being drawn by men. The two occupants holding the parasols seated in the first float are Beulah Erickson (left) and Maurine DeLano.

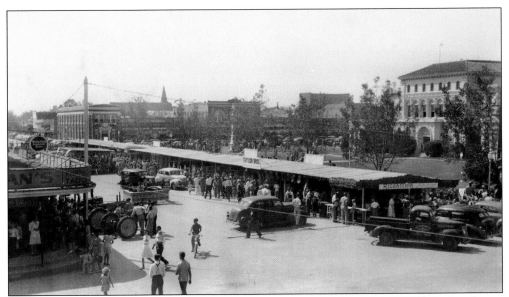

FIRST RICE FESTIVAL. The Bay City Lions Club sponsored its first Rice Festival in 1941. It was held downtown on the courthouse square. The booths shown in this photograph were located on the east side of the square on Avenue G.

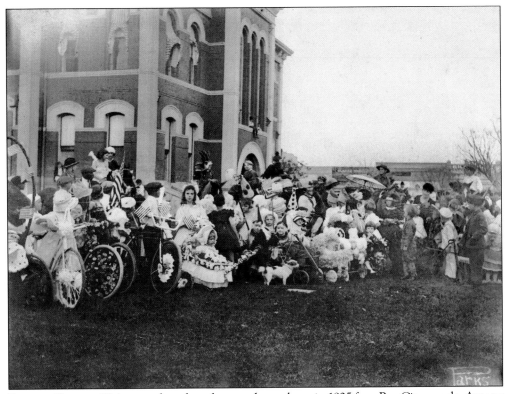

PARADE CROWD. Citizens gathered on the courthouse lawn in 1925 for a Bay City parade. Among the crowd of spectators are a group of children with their decorated bicycles and infants and toddlers in their decorated baby carriages waiting for their turn to march in the parade.

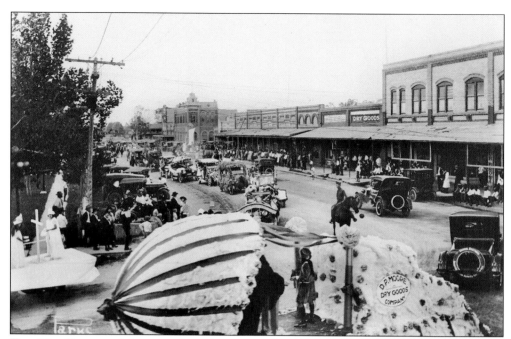

Two-Way Parade. A large number of entries in this 1925 parade forced organizers to change their normal procession. The result was a two-way parade, with floats and cars traveling in both directions around the downtown square in Bay City. The entries on the right are traveling west on Seventh Street while the ones on the left are going east.

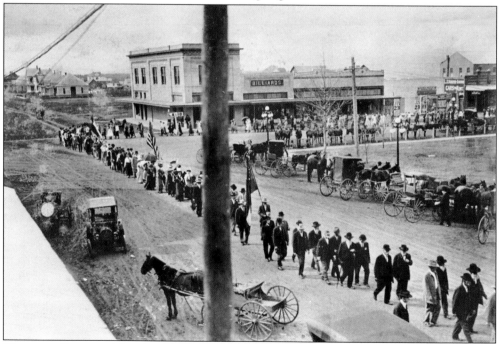

Veterans Parade. After the unveiling of a monument in 1913, the crowd turned their attention to a Veterans Parade around the downtown square, shown here marching east on Sixth Street. The monument was dedicated to Matagorda County Confederate soldiers.

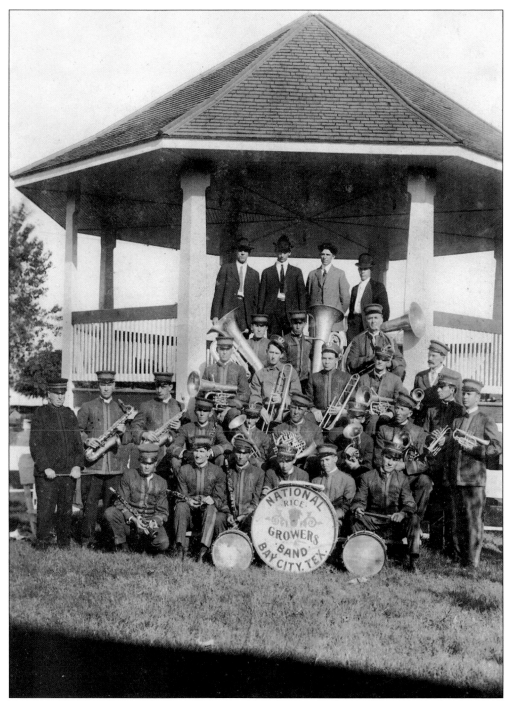

NATIONAL RICE GROWERS BAND. The National Rice Growers Band of Bay City performed many concerts throughout Matagorda County in the early 1900s. Many of their performances were played on the bandstand located on the lawn of the county courthouse, shown in this photograph.

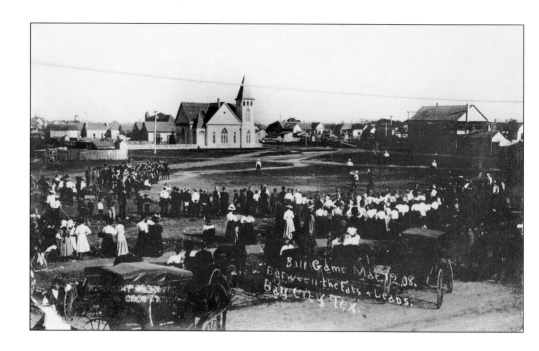

GAME TIME. In 1908, Bay City had two baseball teams with opposite names, the Fats and the Leans. This game (pictured above) on March 12, 1908, drew a large crowd from the area. The spectators did not have the luxury of a baseball stadium or portable chairs, so they stood as they watched the game. The photograph below indicates that the physical build of each team reflected their names. In the background of both photographs is the First Presbyterian Church, located on Avenue H.

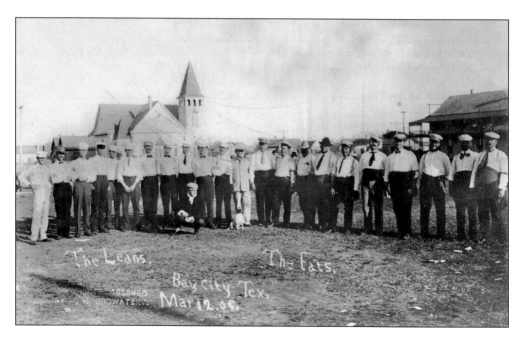

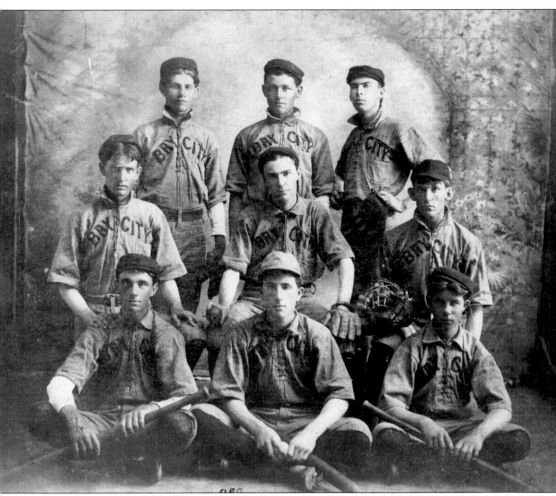

BAY CITY BALL TEAM. In 1904, Bay City's second baseball team was organized. Team members from left to right are (first row) center fielder, O. Franz; pitcher and second baseman, R. W. Benge; and left fielder, A. Harrison; (second row) second baseman and pitcher, Jim Tabb; shortstop, O. W. Ziegenhals; and catcher, C. F. Landergren; (third row) right fielder, A. Harper; third baseman, M. Kraatz; and first baseman, J. B. McCann.

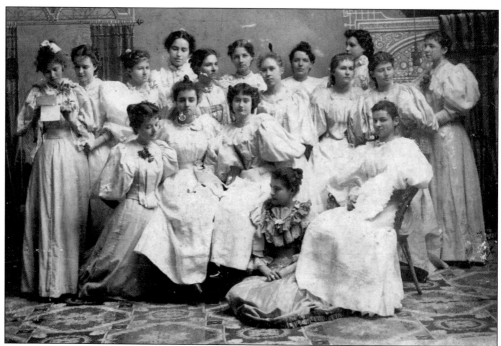

MUSIC STUDENTS. This group of lovely young ladies is dressed in their finest to perform a recital around the year 1895. They learned their talent and appreciation for music through their instructor, Imogene Castleton.

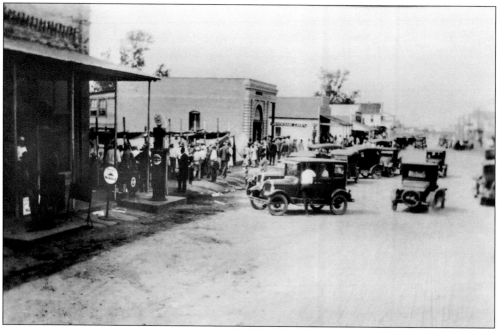

MARKHAM CELEBRATION. Markham townsfolk flock to carnival booths set up on the main street during a 1924 celebration. From left to right are Jack Walker Hardware and Mobile Service, carnival booths, Markham State Bank, the post office, Fred Miller's Garage, R. A. Wendt Meat Market, and Sig Brown Grocery and General Merchandise, with living quarters above.

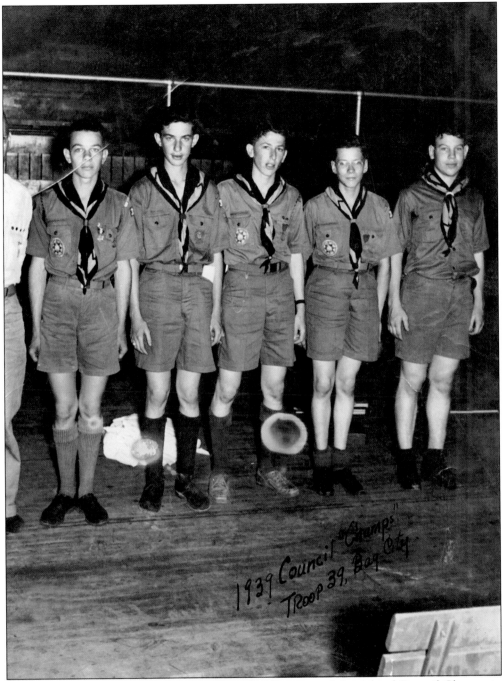

BOY SCOUTS. Boy Scout Troop No. 39 from Bay City earned the title of Council Champs in 1939. Troop No. 39 received its charter in 1933.

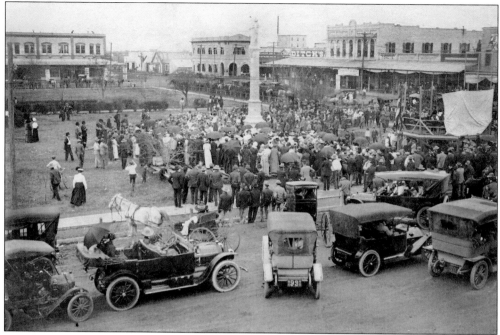

MONUMENT DEDICATION. In 1913, the Captain E. S. Rugeley Chapter No. 542 of the United Daughters of the Confederacy erected a monument on the courthouse square dedicated to the Matagorda County Confederate soldiers. The unveiling of this monument occurred on January 17, 1913, with around 3,000 citizens attending the ceremony.

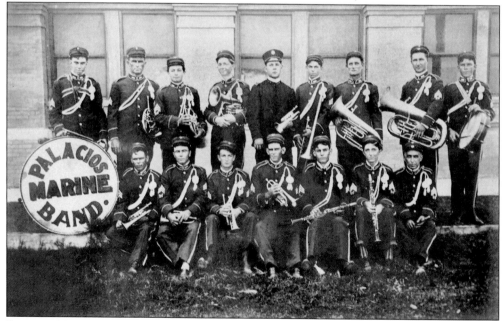

PALACIOS MARINE BAND. The members of the Palacios Marine Band played frequently, entertaining the people of Palacios and the surrounding areas. Most of their performances were held at either the park, located at the corner of Fifth and Haber (now Commerce) Streets, or on the Palacios Hotel porch.

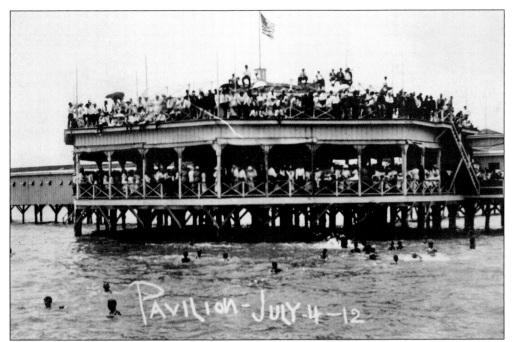

PALACIOS PAVILION. The pavilion built on the shore of Palacios was one of the sites for fun-filled entertainment throughout the year. This photograph shows a Fourth of July celebration held at the pavilion in 1912. People walked along the pier to enter the pavilion; bathhouses were located on the east and west sides to accommodate swimmers. The lower deck was often used for dances or skating, and a boat pier on the south side provided a place where boaters could tie up.

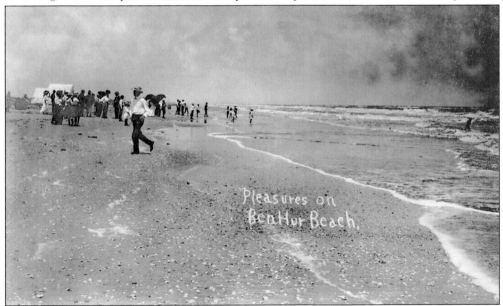

BEACH EXCURSION. People often gathered for fun-filled days at Ben Hur Beach on Matagorda Peninsula, as shown in this photograph taken around 1909. They would indulge in barbecues, participate in ball games, cool off in the water, and enjoy fishing in the surf. Dozens of sailboats would transport passengers across the bay to and from Ben Hur Beach.

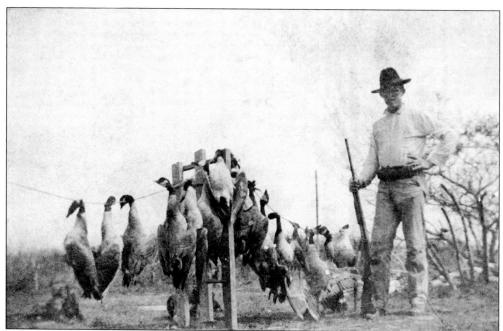

GOOSE HUNT. On this particular day early in the 1900s, Fred Gillette had a successful goose hunting trip in Matagorda County. He is shown here with more than a dozen birds, ready for cleaning and cooking.

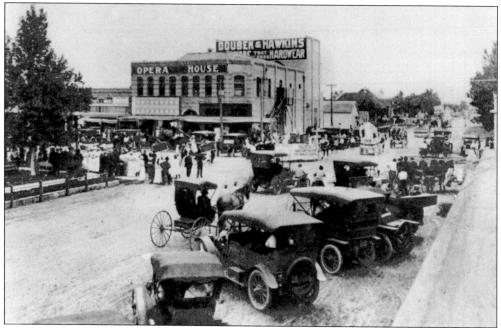

OPERA HOUSE. The grand opening for the Bay City Opera House, located at the corner of Sixth Street and Avenue F, was held on December 21, 1908. The show *The Woman's Hour* featuring Adelaide Thurston was presented at the opening. A storm in 1909 destroyed part of the building, but it was quickly repaired, and manager O. J. Doubek continued booking entertaining road shows. In 1932, it was sold to J. G. Long, who turned it into the Franklin Movie Theater.

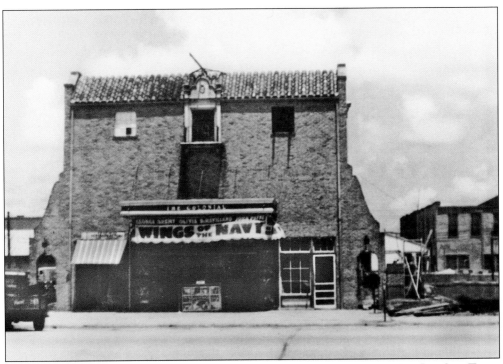

COLONIAL THEATER. In 1927, the Colonial Theater was built at 2227 Avenue F in Bay City, Texas, by May Brunner, James Preddy, and P. R. Hamill. It was sold to J. G. Long in 1929. It continued to operate as the Colonial until 1939, when it was closed and remodeled. It reopened as the Texas Theater on November 23 of that same year. It closed its doors for good in 1981; today it is the home of the Rhema Fellowship Church.

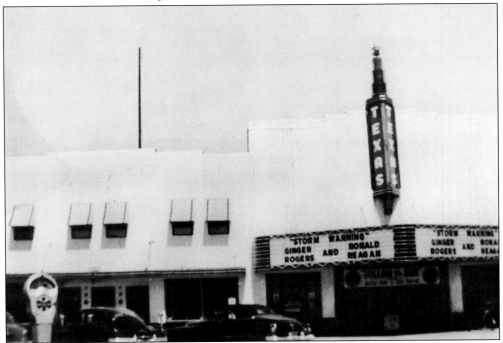

Discover Thousands of Local History Books Featuring Millions of Vintage Images

Arcadia Publishing, the leading local history publisher in the United States, is committed to making history accessible and meaningful through publishing books that celebrate and preserve the heritage of America's people and places.

Find more books like this at
www.arcadiapublishing.com

Search for your hometown history, your old stomping grounds, and even your favorite sports team.

Consistent with our mission to preserve history on a local level, this book was printed in South Carolina on American-made paper and manufactured entirely in the United States. Products carrying the accredited Forest Stewardship Council (FSC) label are printed on 100 percent FSC-certified paper.

MADE IN THE USA

IMAGES
of America

WEST SEATTLE

Southwest Seattle Historical Society,
Log House Museum